mythomorphia

KERBY ROSANES

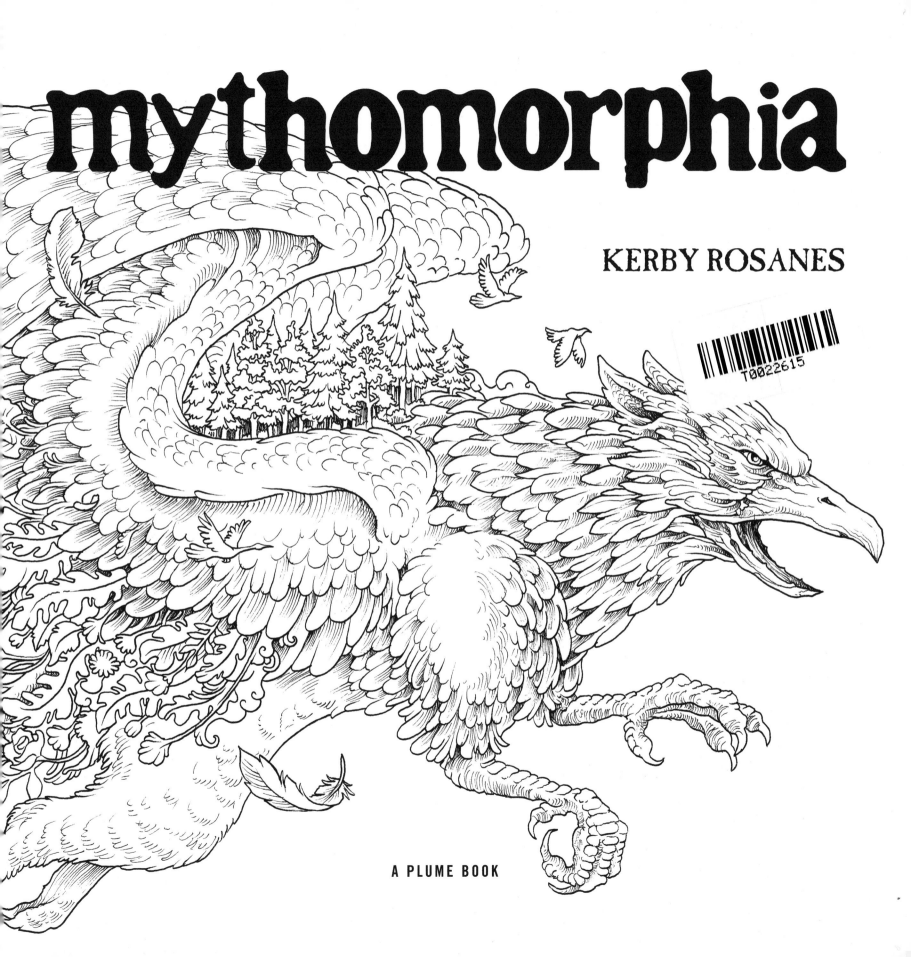

A PLUME BOOK

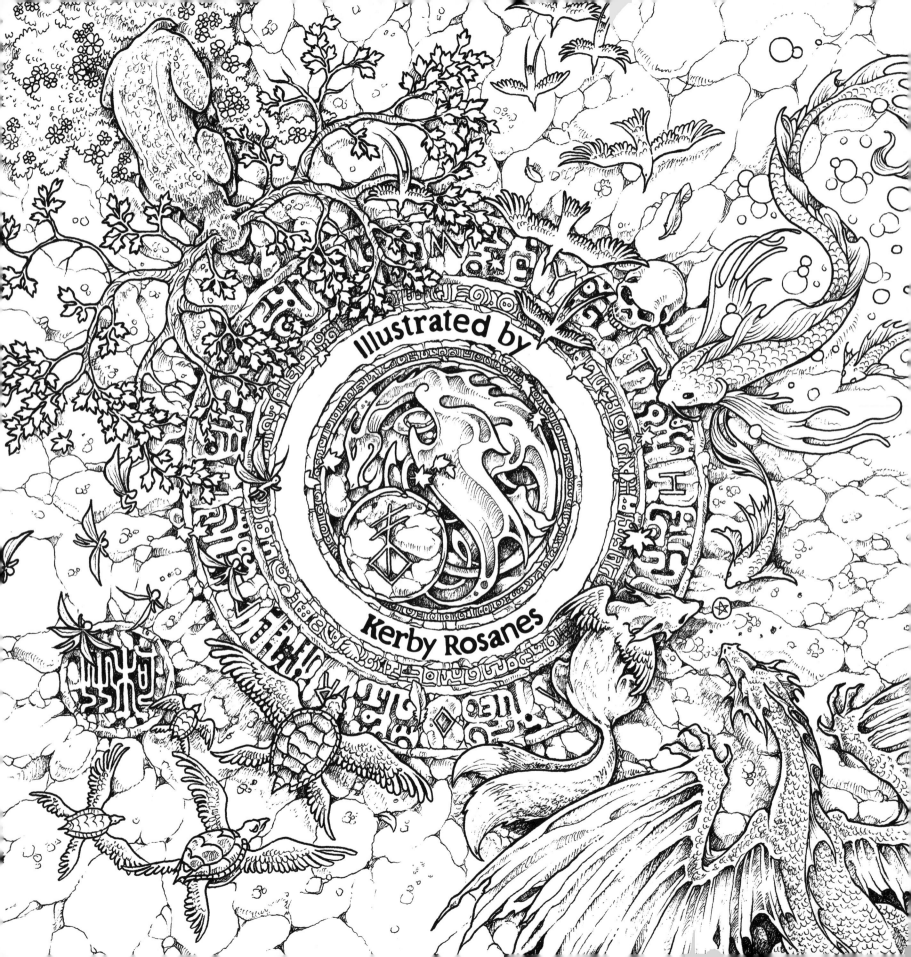

Illustrated by

Kerby Rosanes

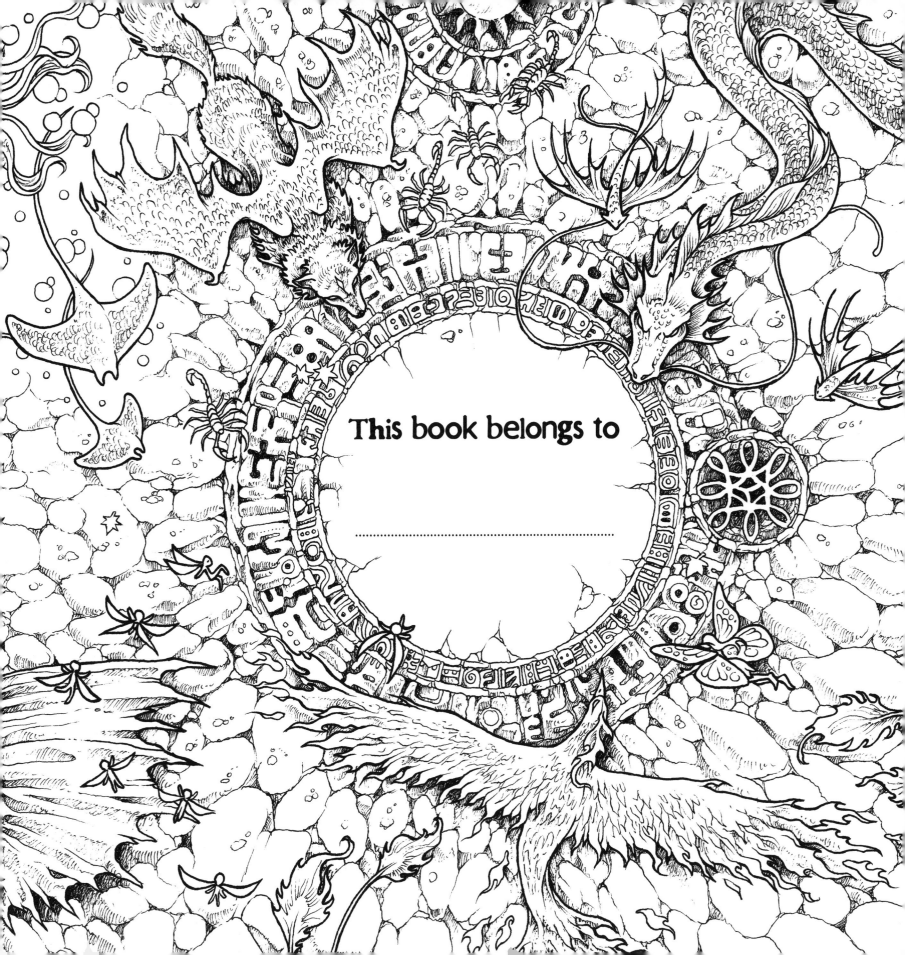

This book belongs to

Edited by Lauren Farnsworth
Designed by Derrian Bradder
Cover Design by Angie Allison
and John Bigwood

With thanks to Harry Thornton
for being a great talent scout

P

PLUME
An imprint of Penguin Random House LLC
375 Hudson Street
New York, New York 10014

First published in Great Britain in 2017 by
LOM ART, an imprint of Michael O'Mara Books Limited,
9 Lion Yard, Tremadoc Road, London SW4 7NQ

ISBN 9780735211094

Printed in China
13

Explore this mythological coloring adventure!

Delve into my high-definition, super-detailed doodle world, where creatures from myth and legend come to life and morph out of their fantastical surroundings.

Each detailed drawing has been crafted with fineliner pens and can be colored in any way you like.

Watch out for unusual objects scattered throughout the pages. You'll find a list of hidden treasures that you need to search for at the back of the book (along with all the answers).

Kerby Rosanes

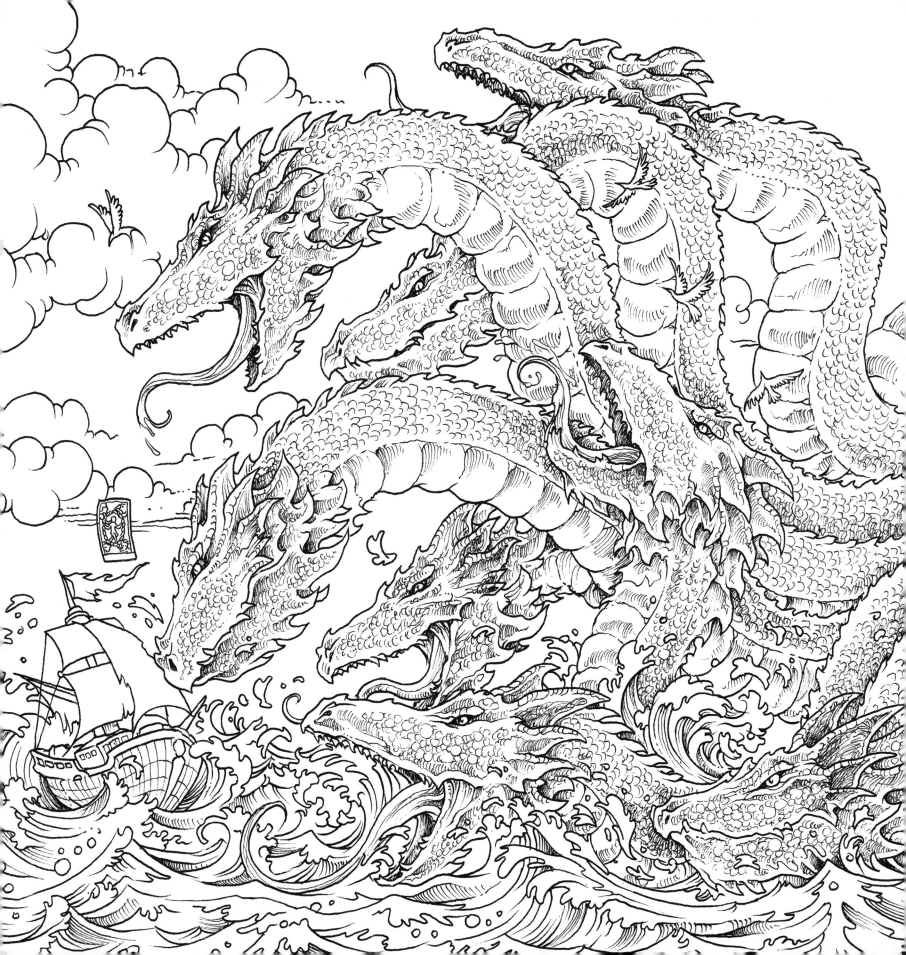

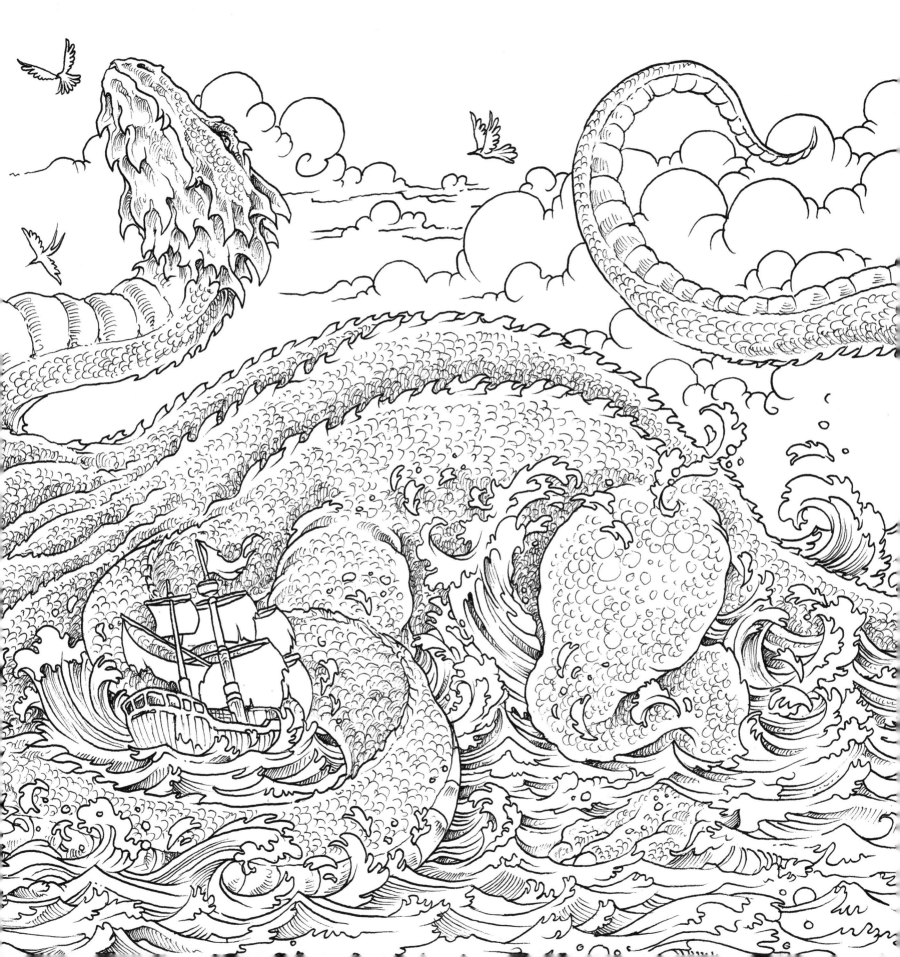

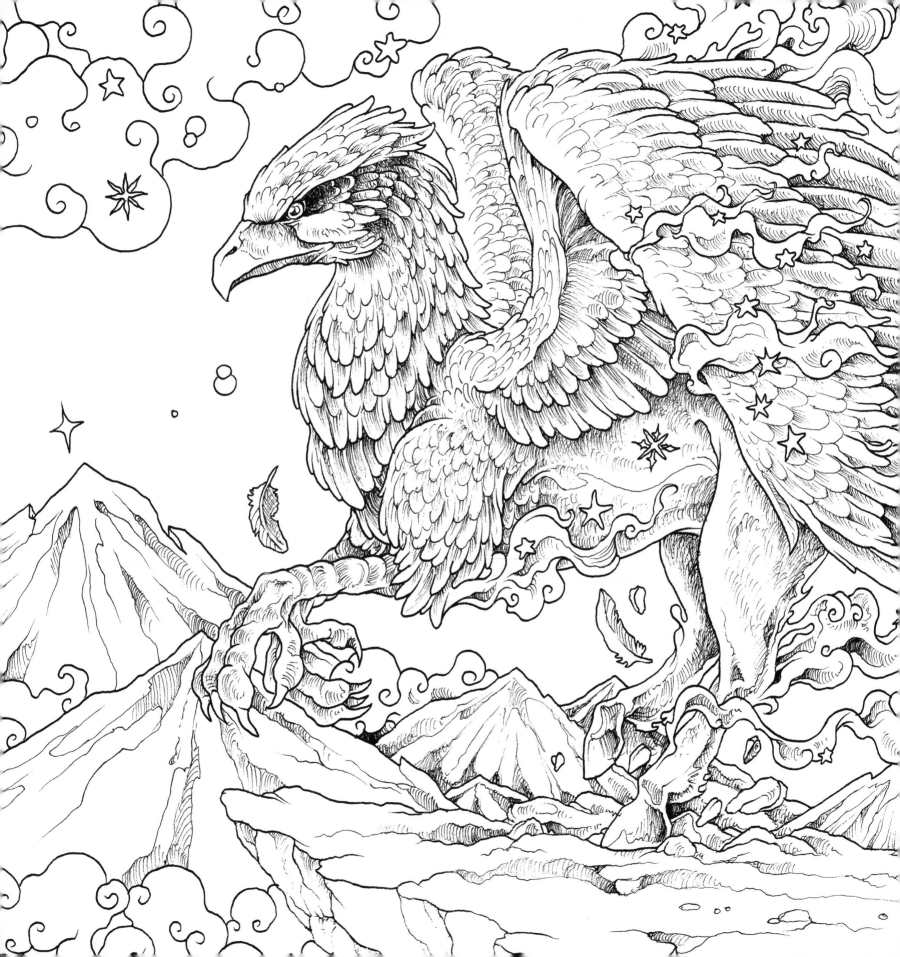

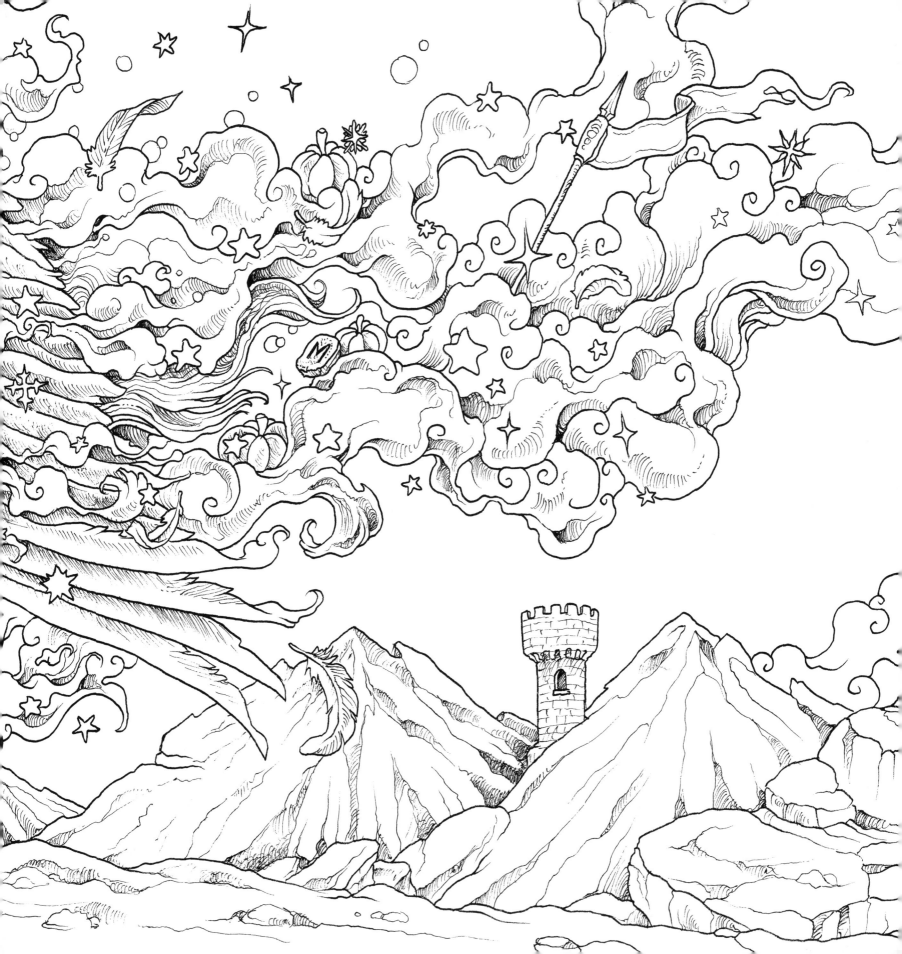

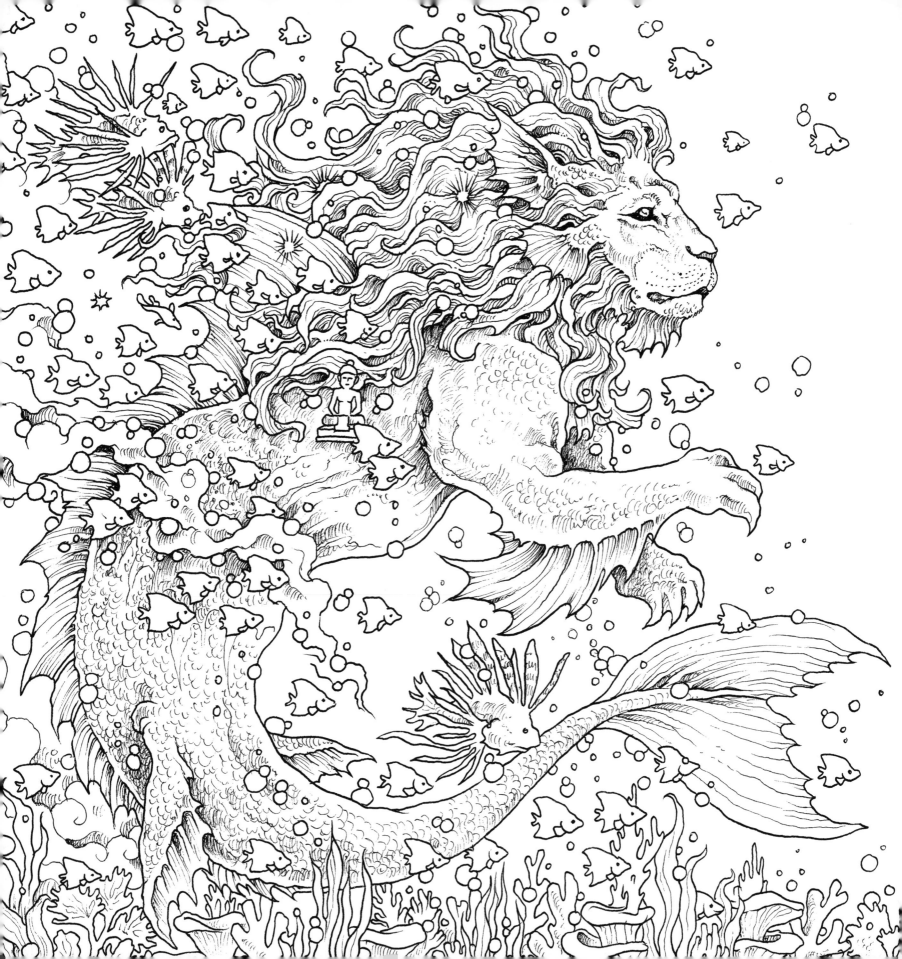

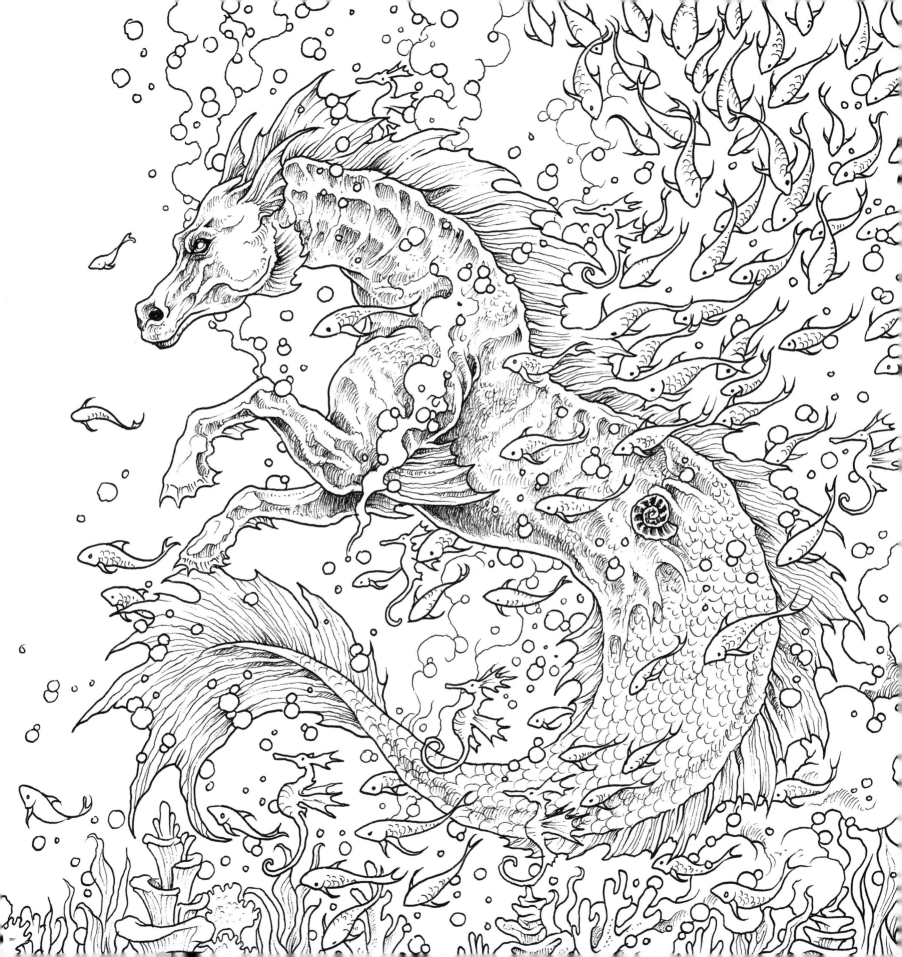

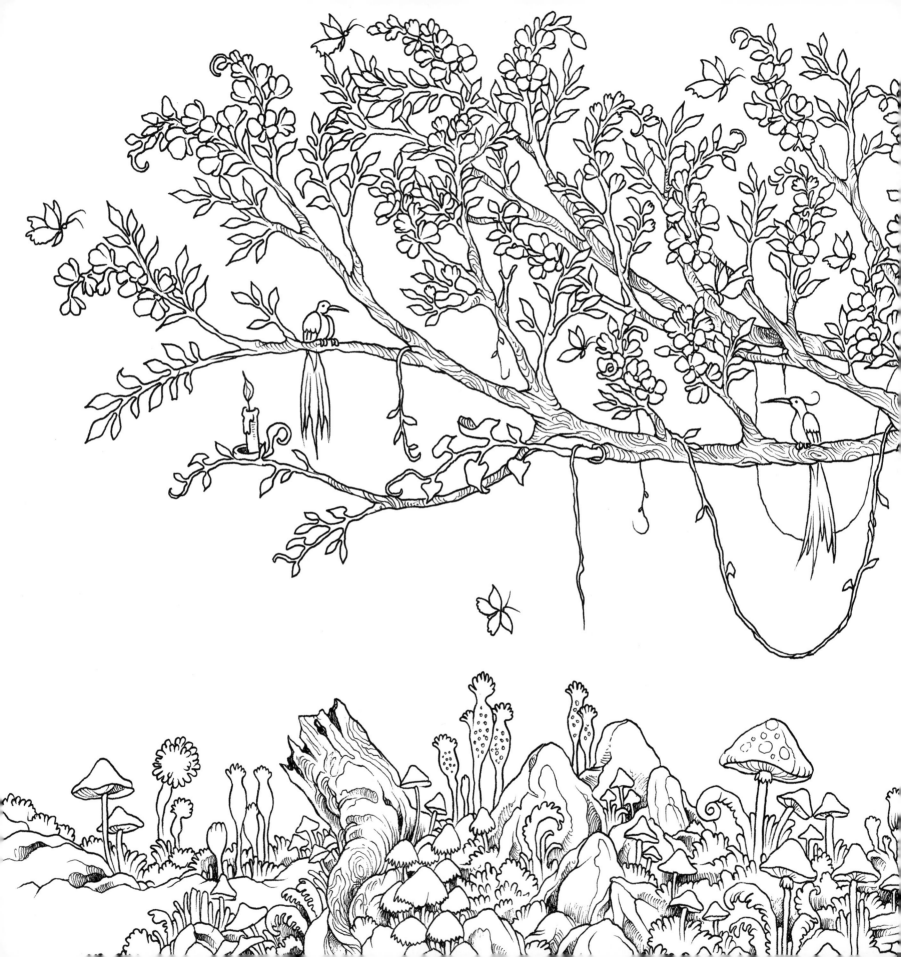

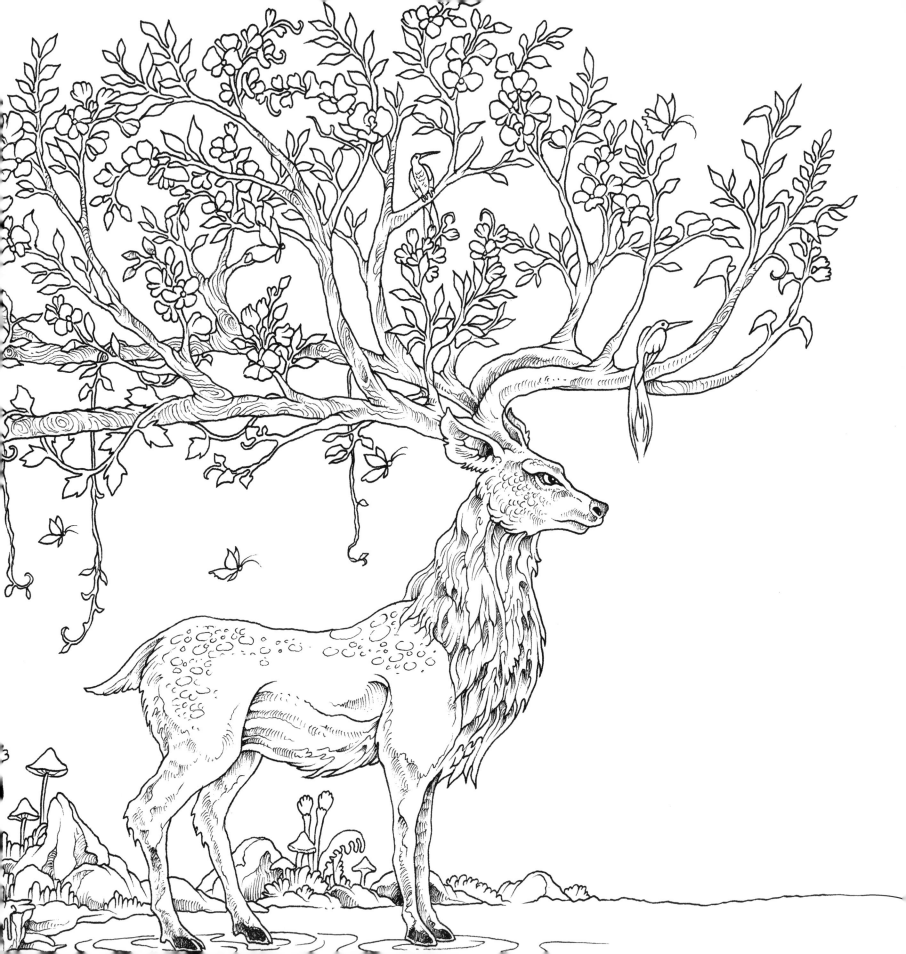

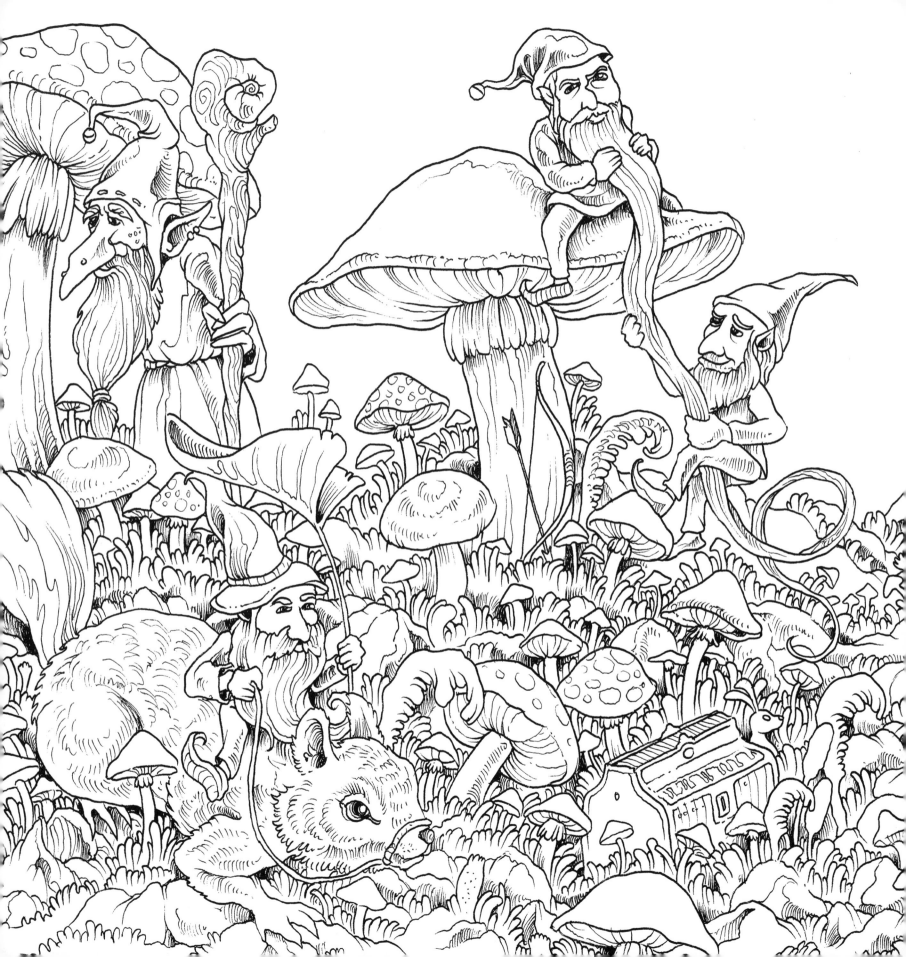

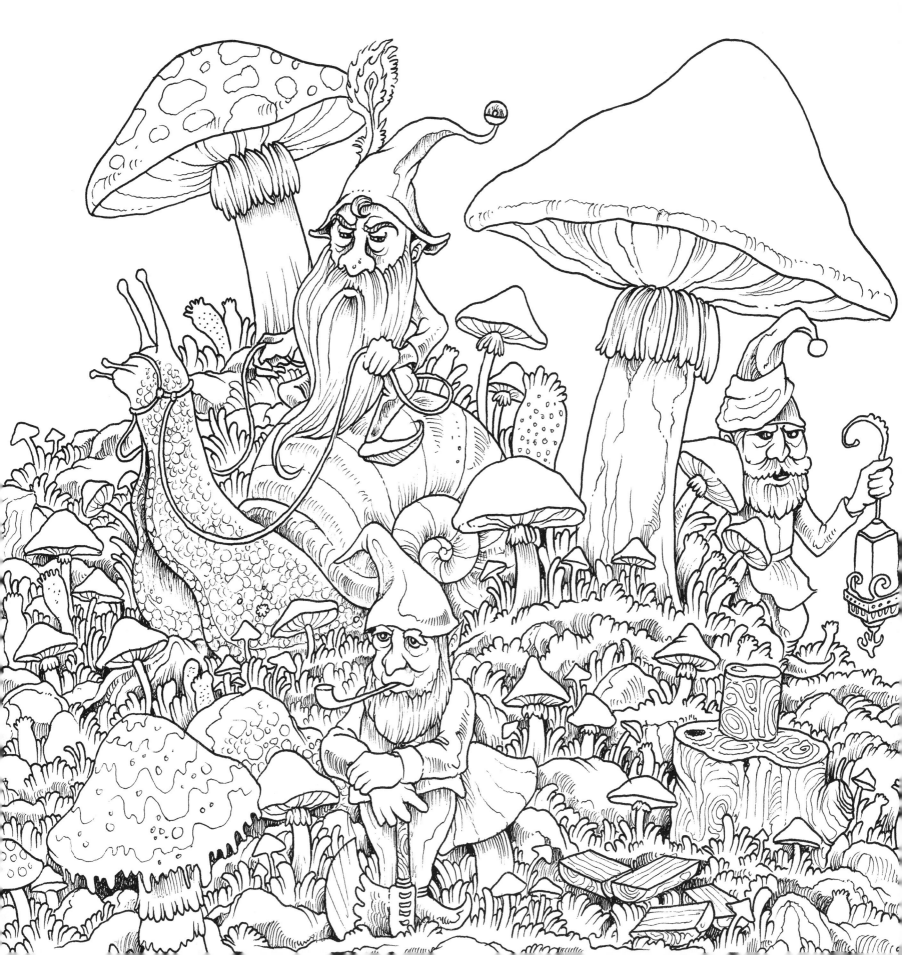

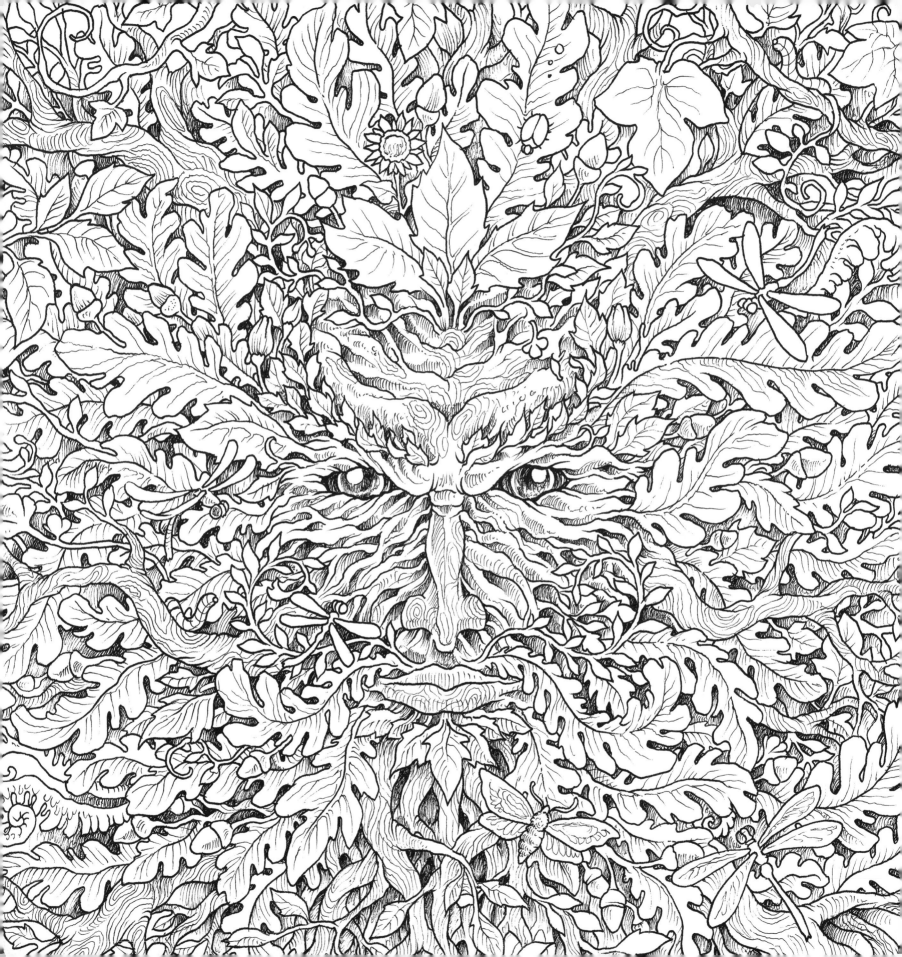

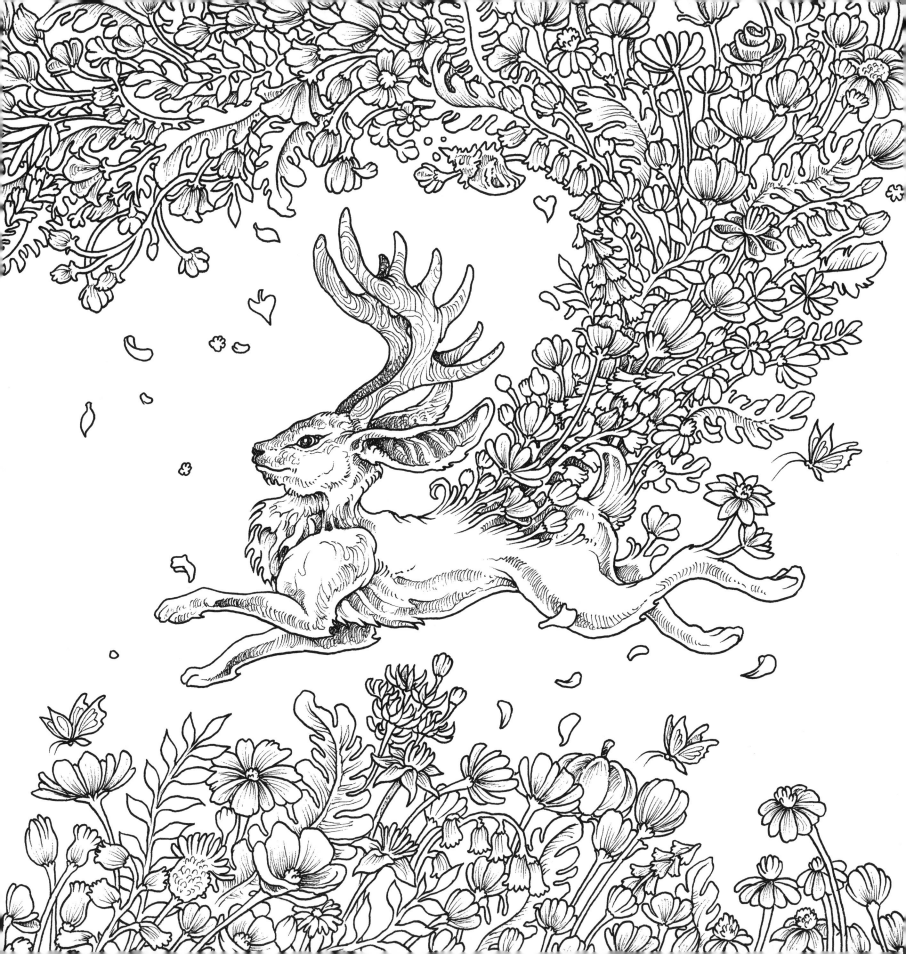

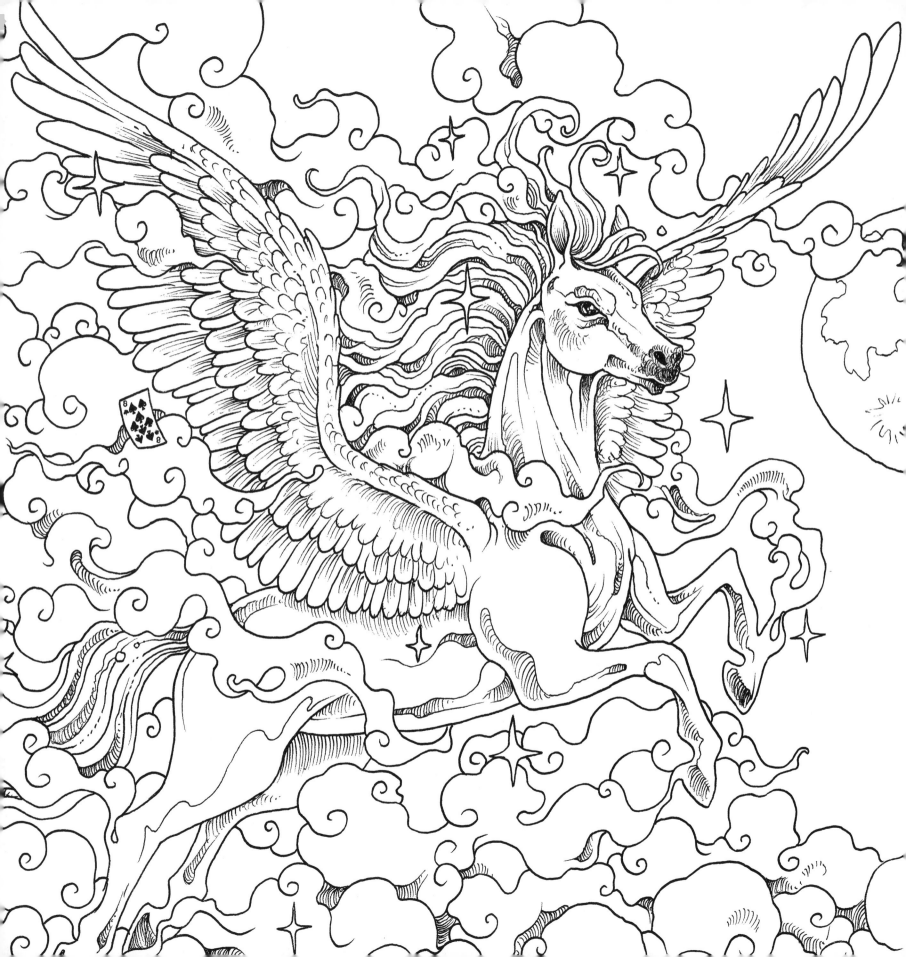

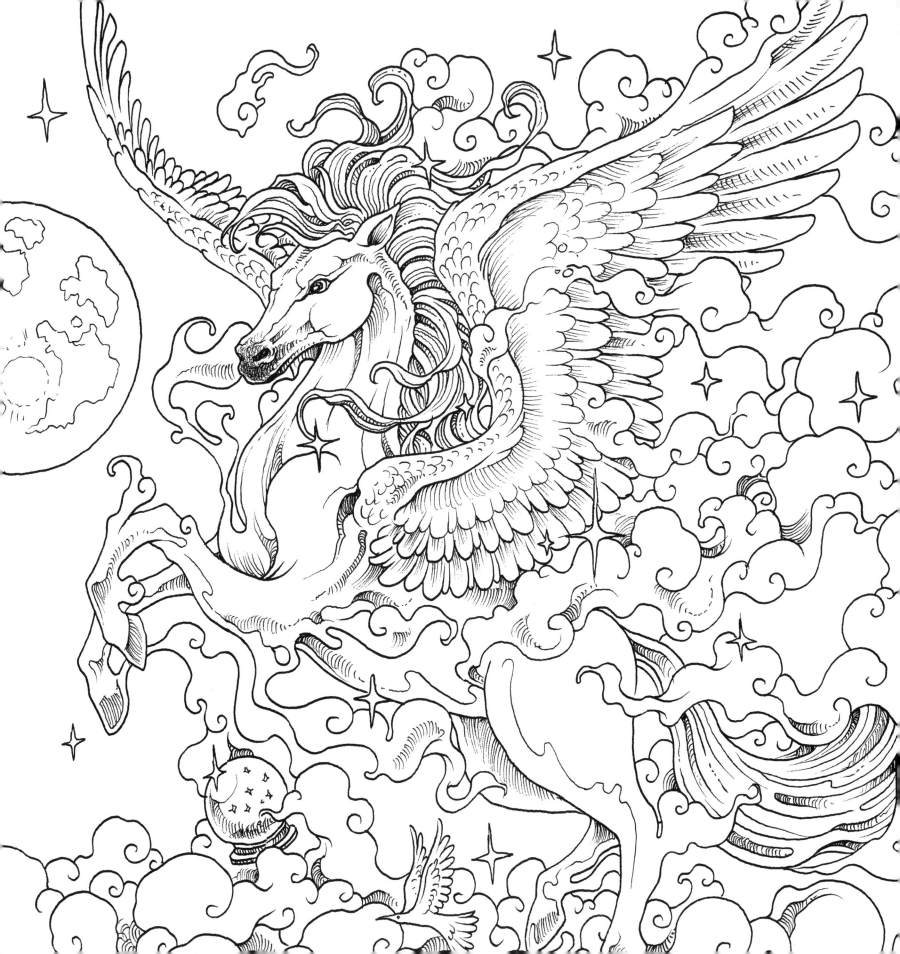

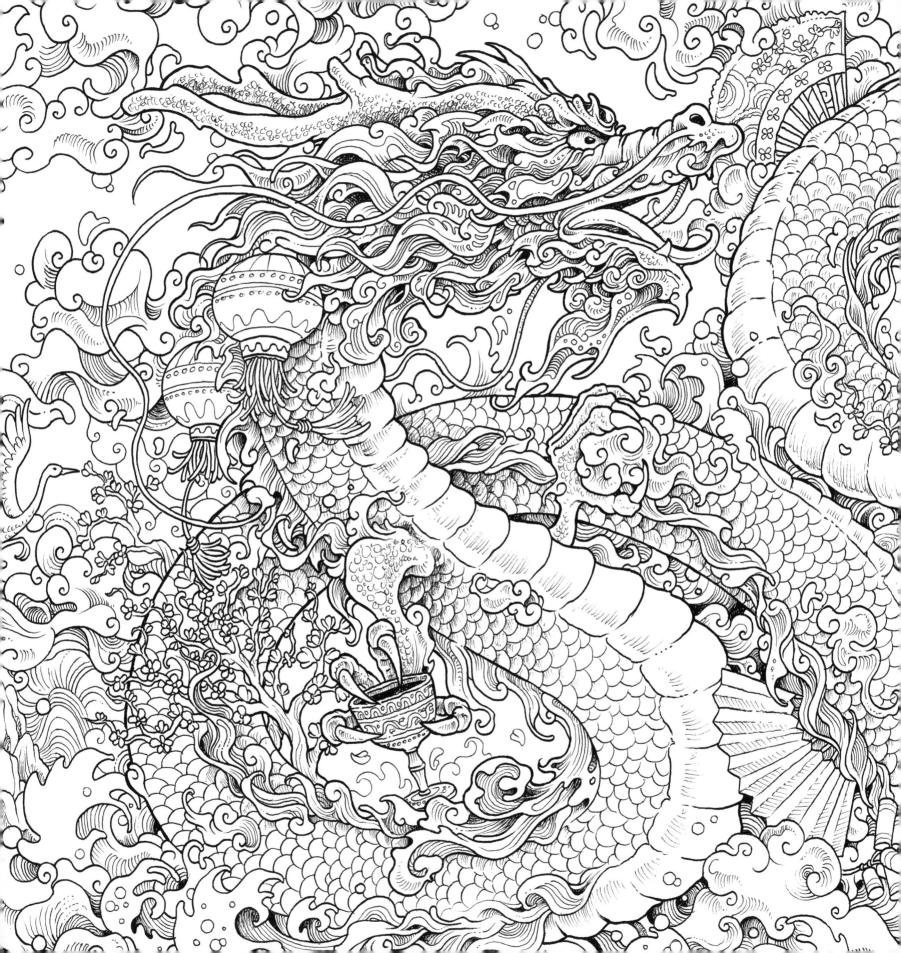

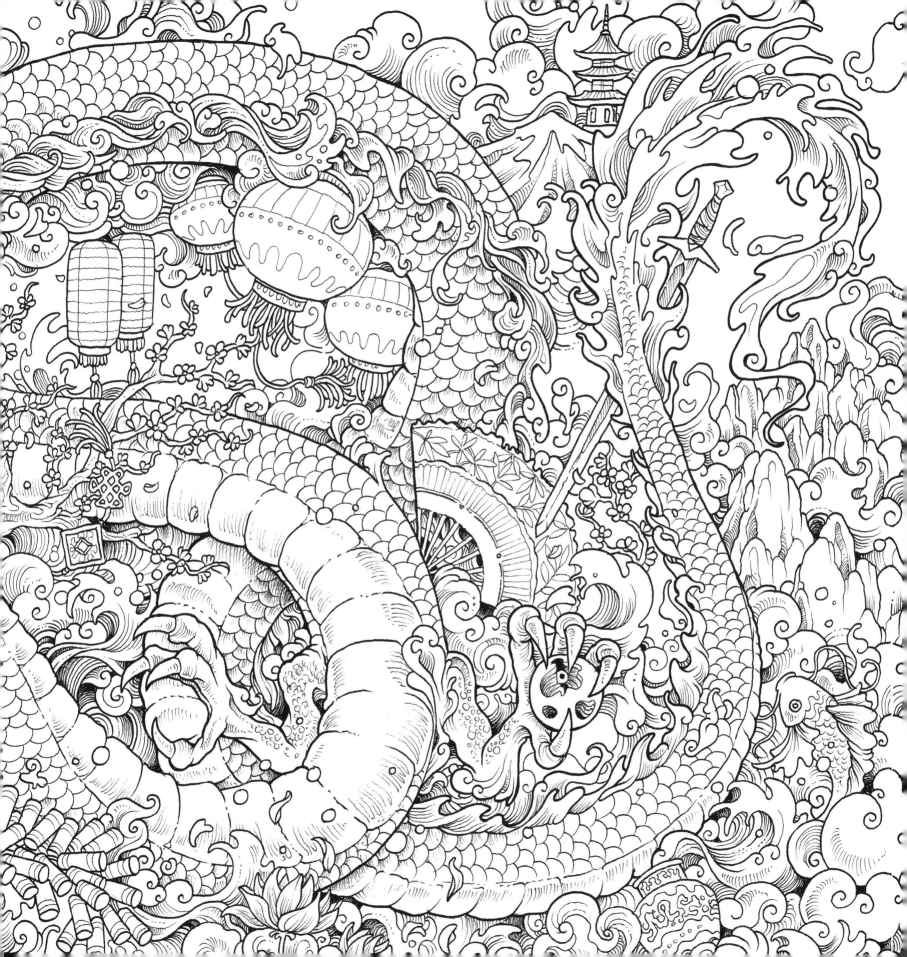

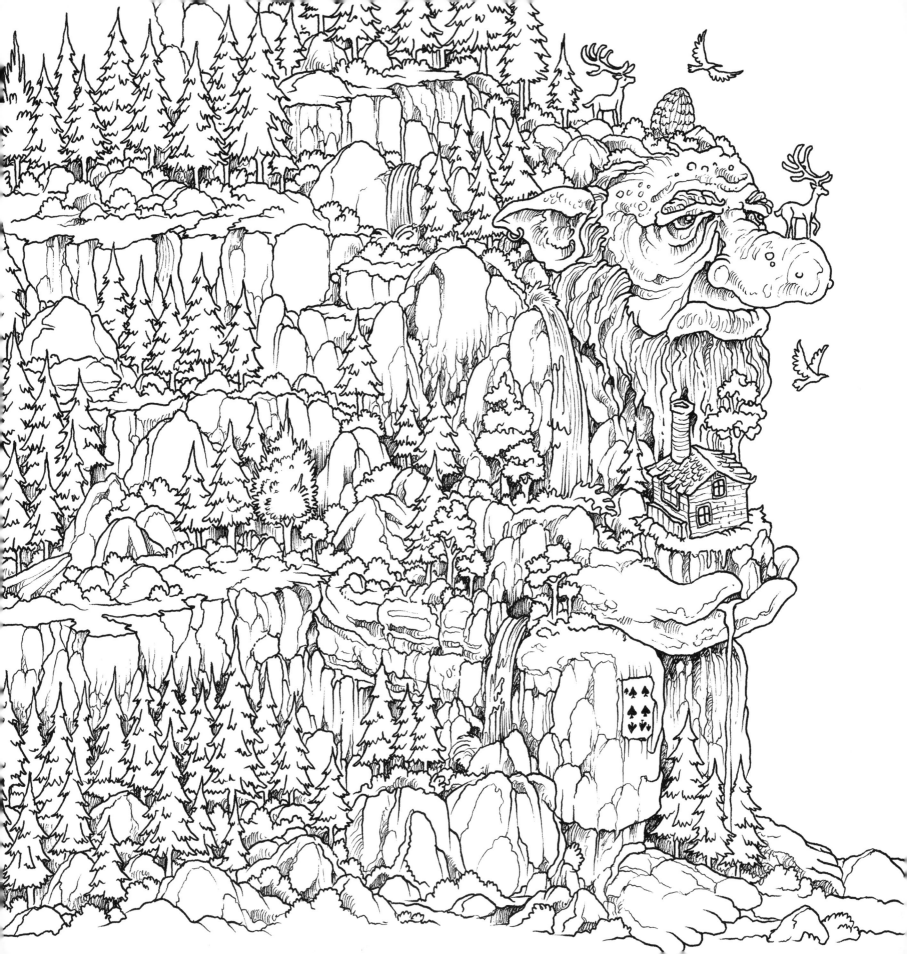

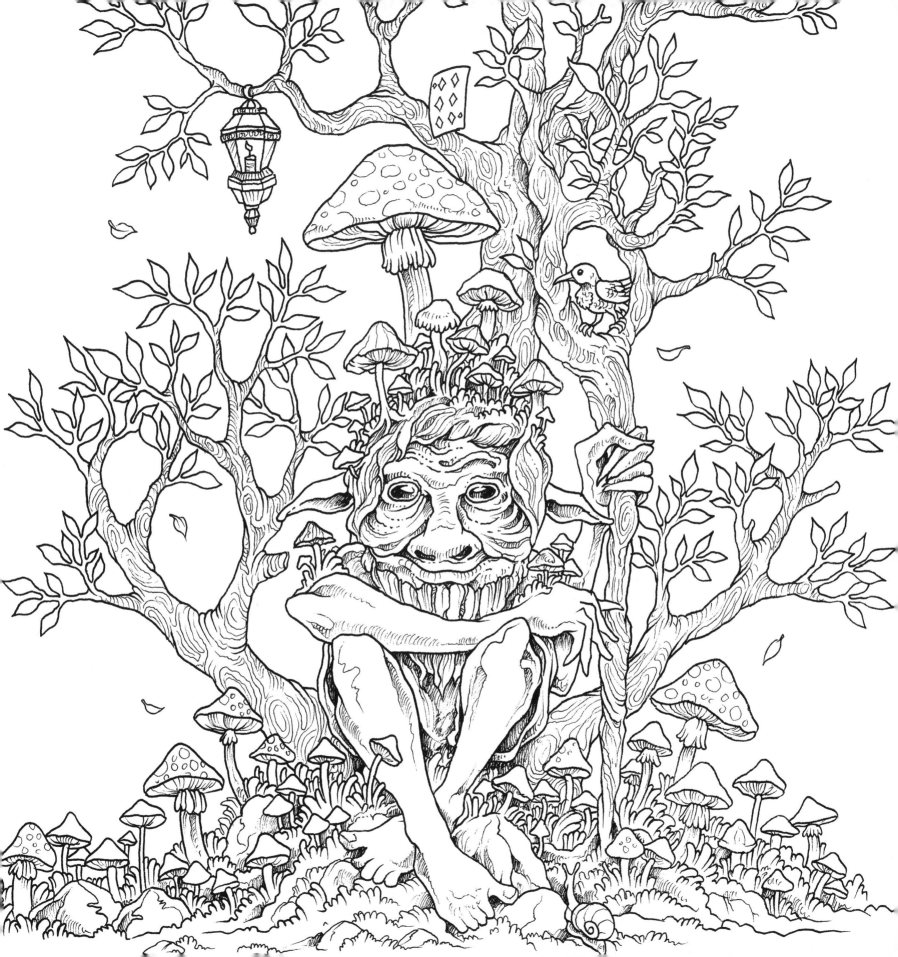

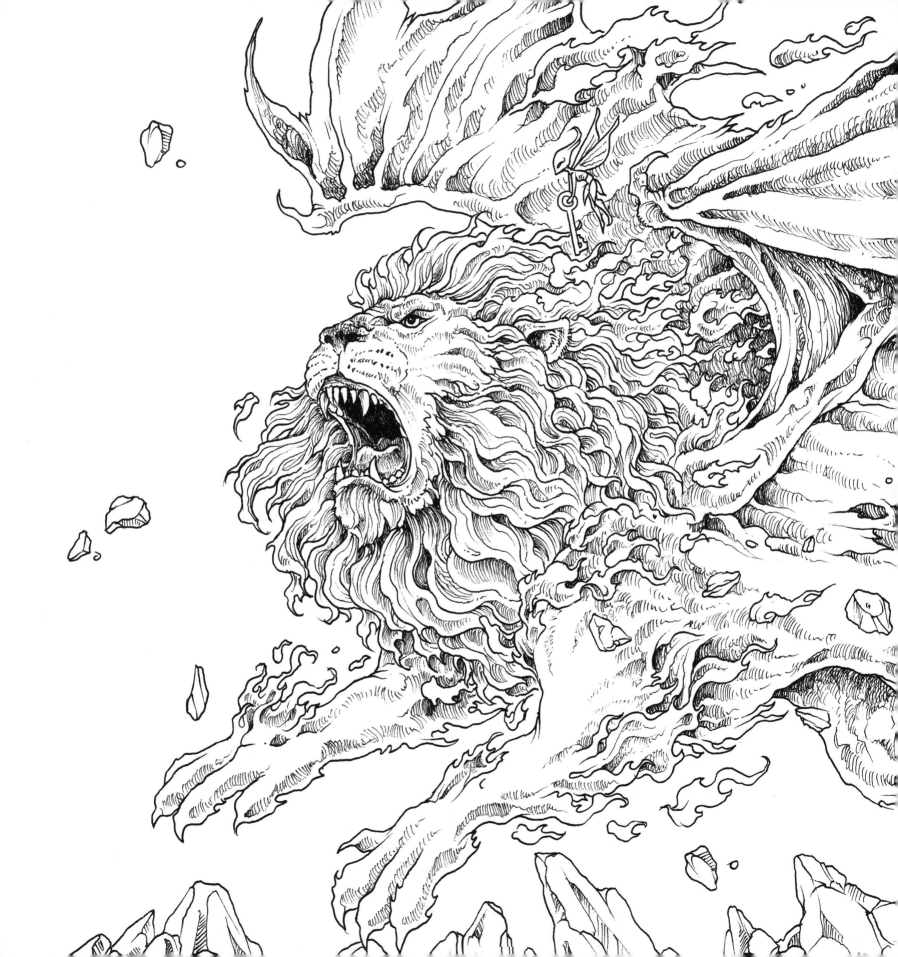

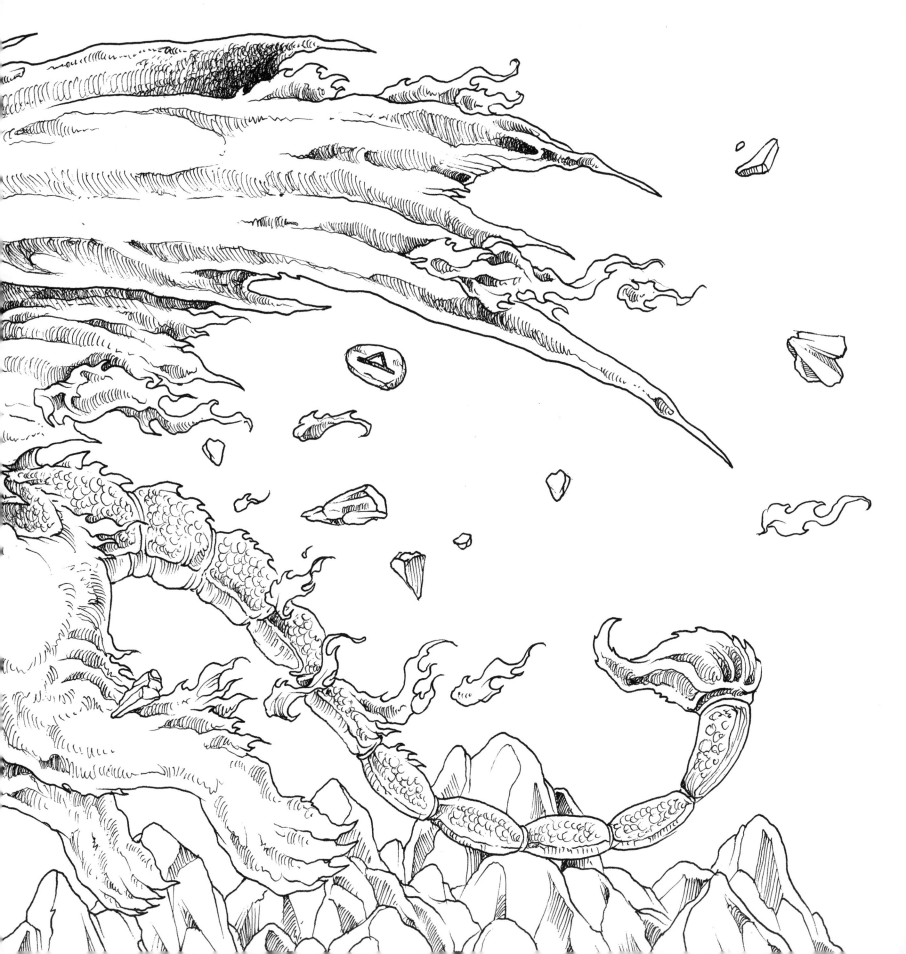

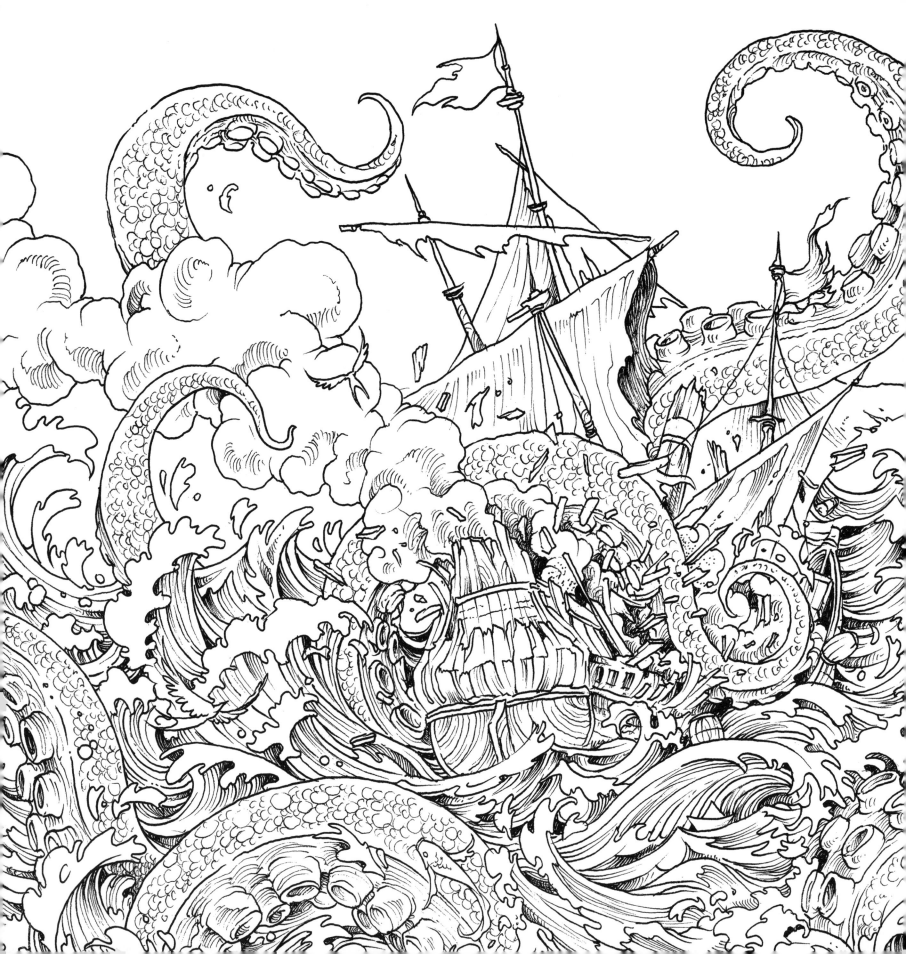

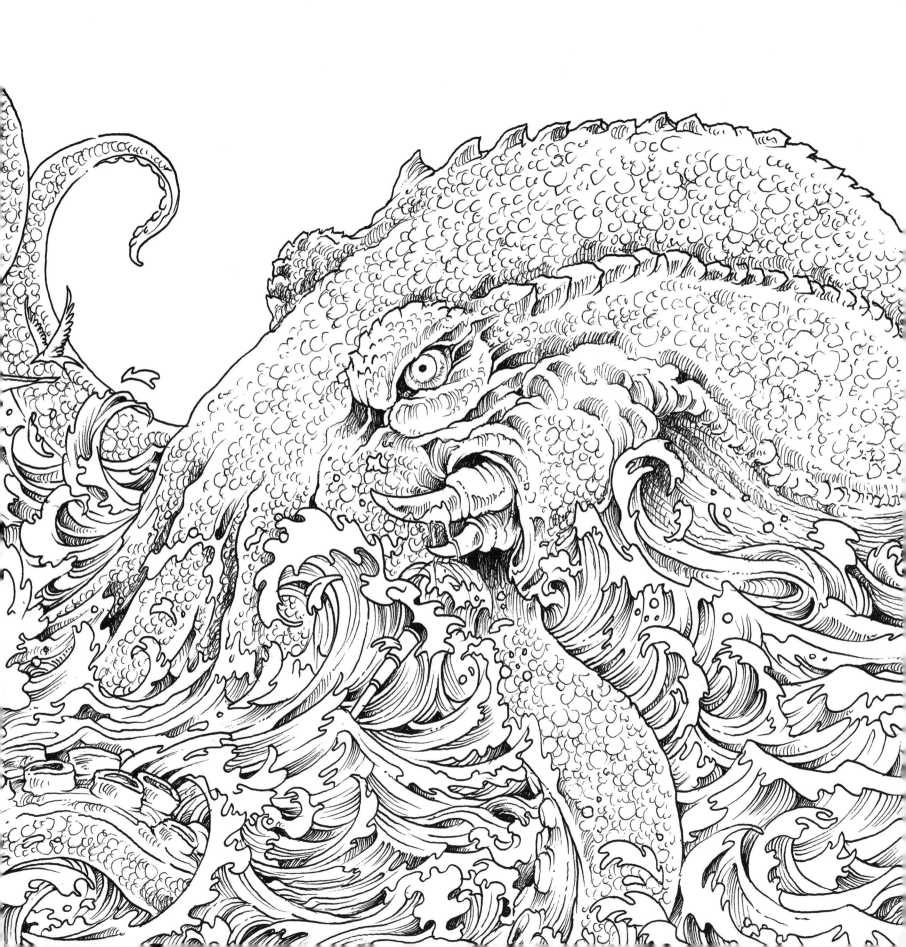

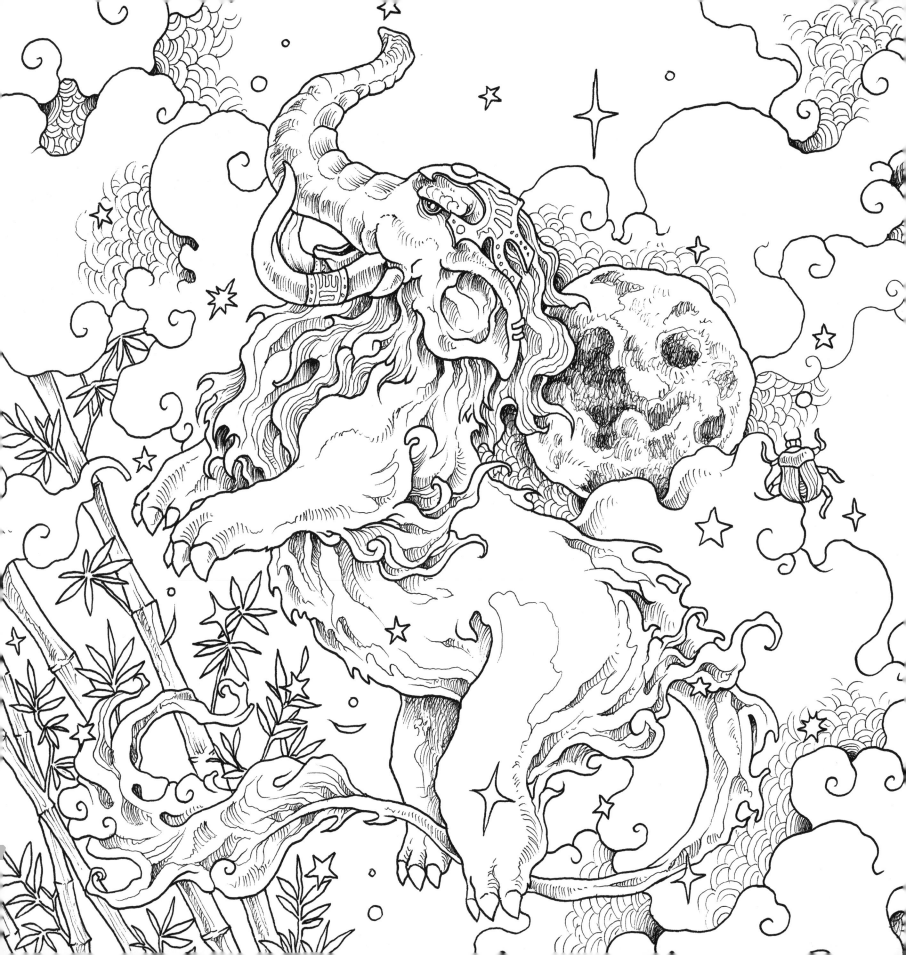

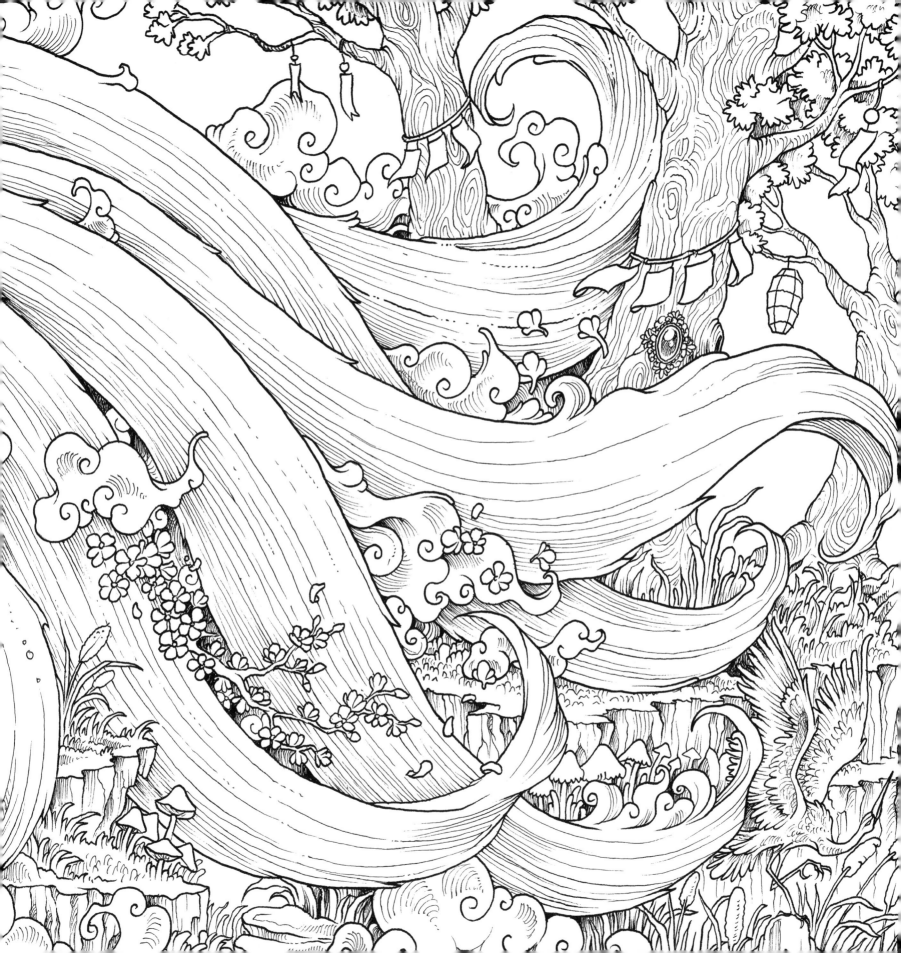

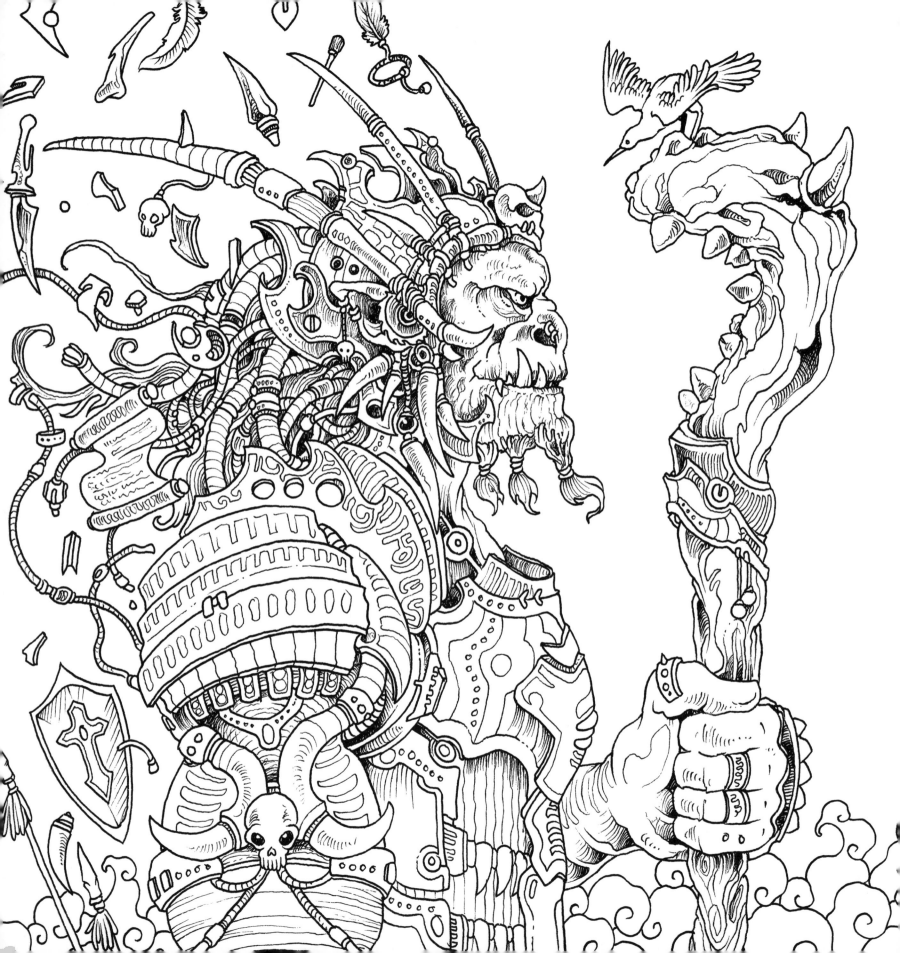

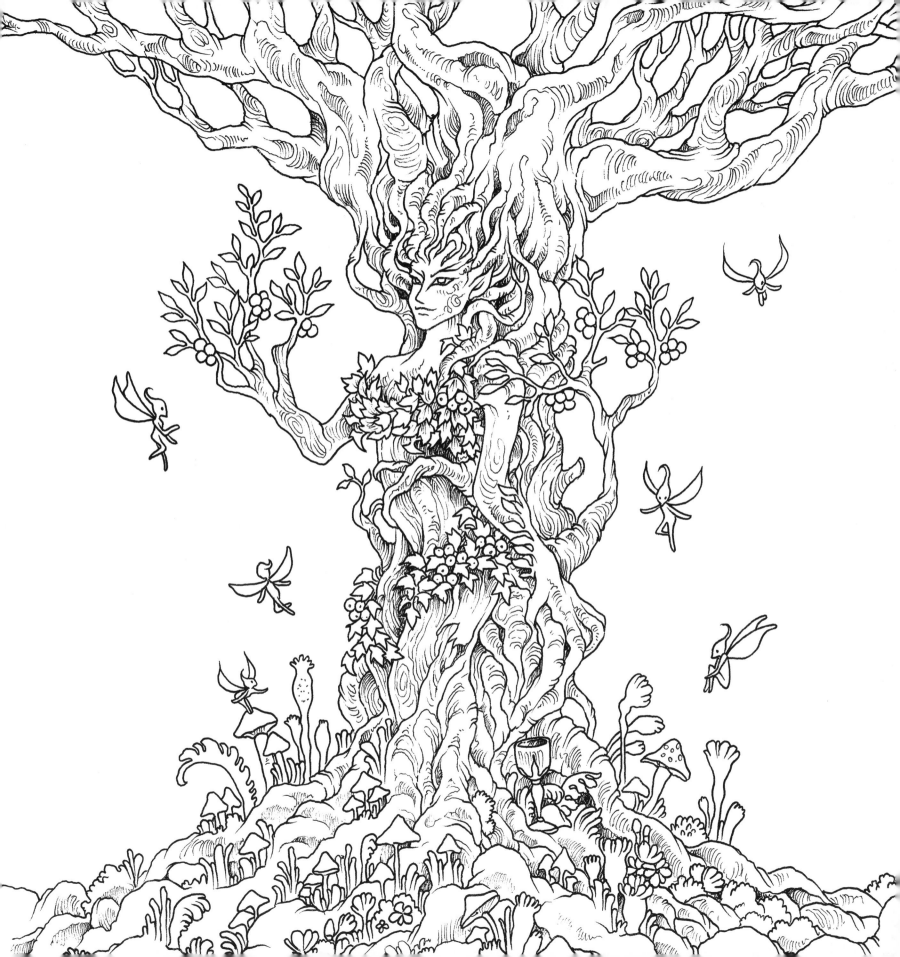

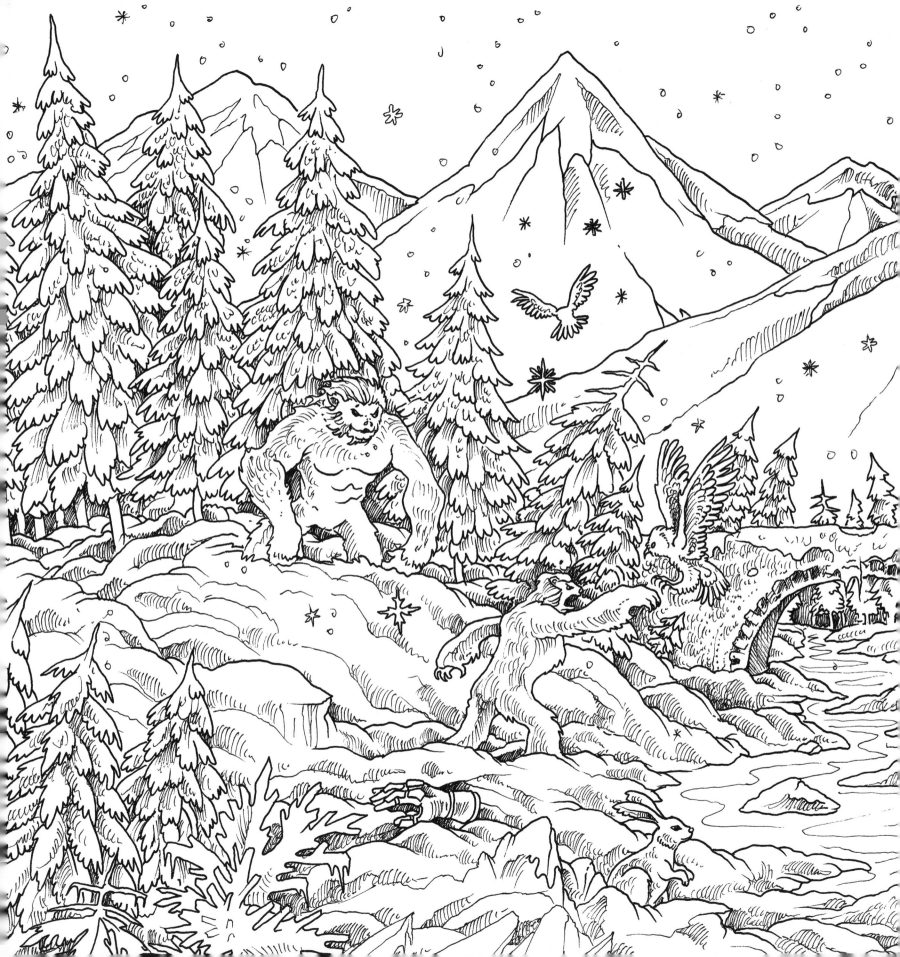

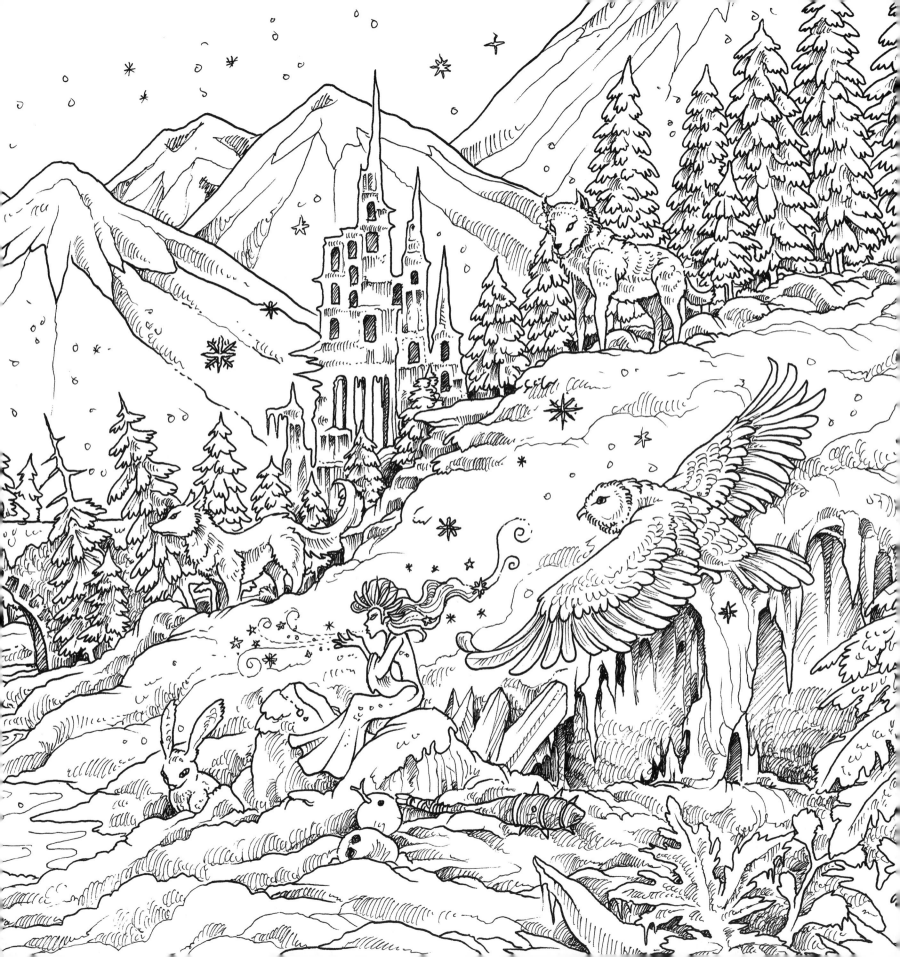

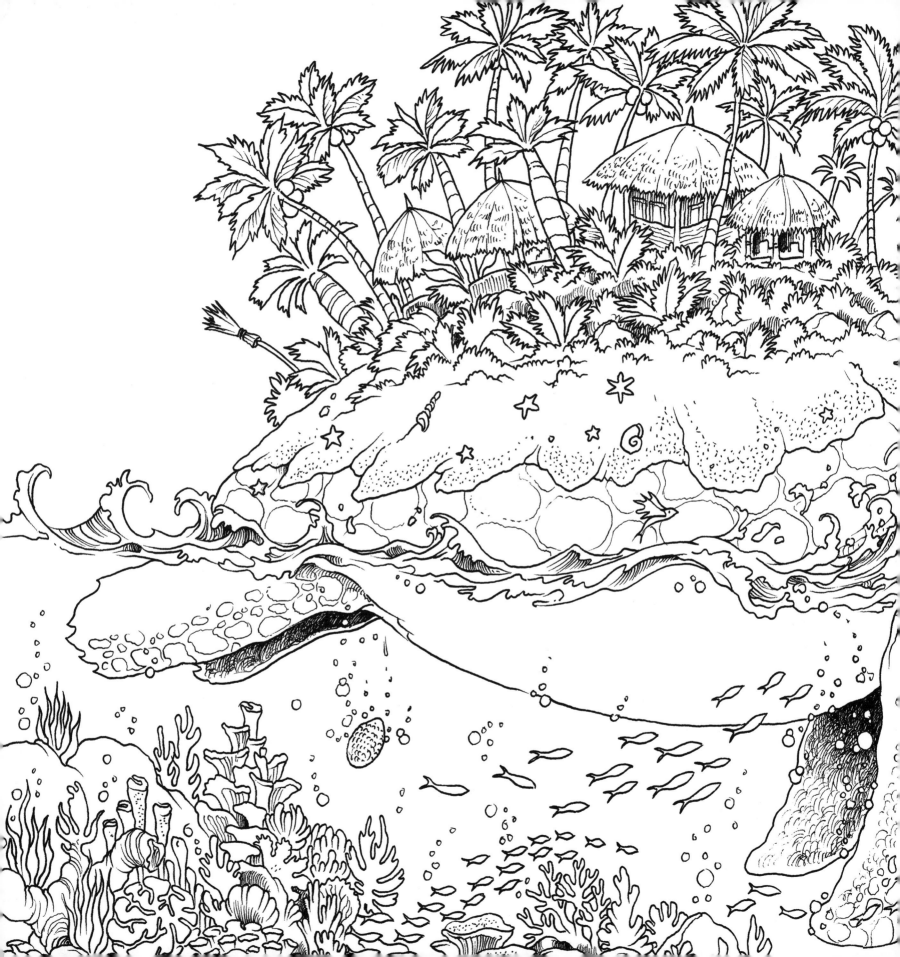

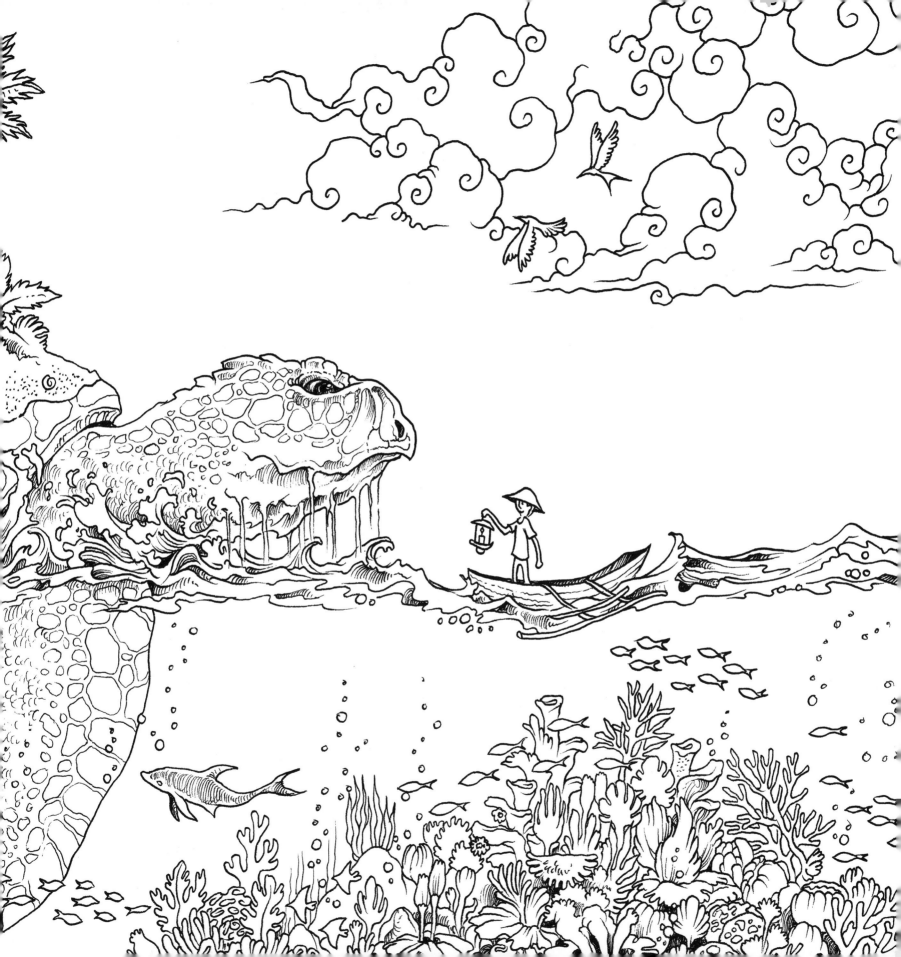

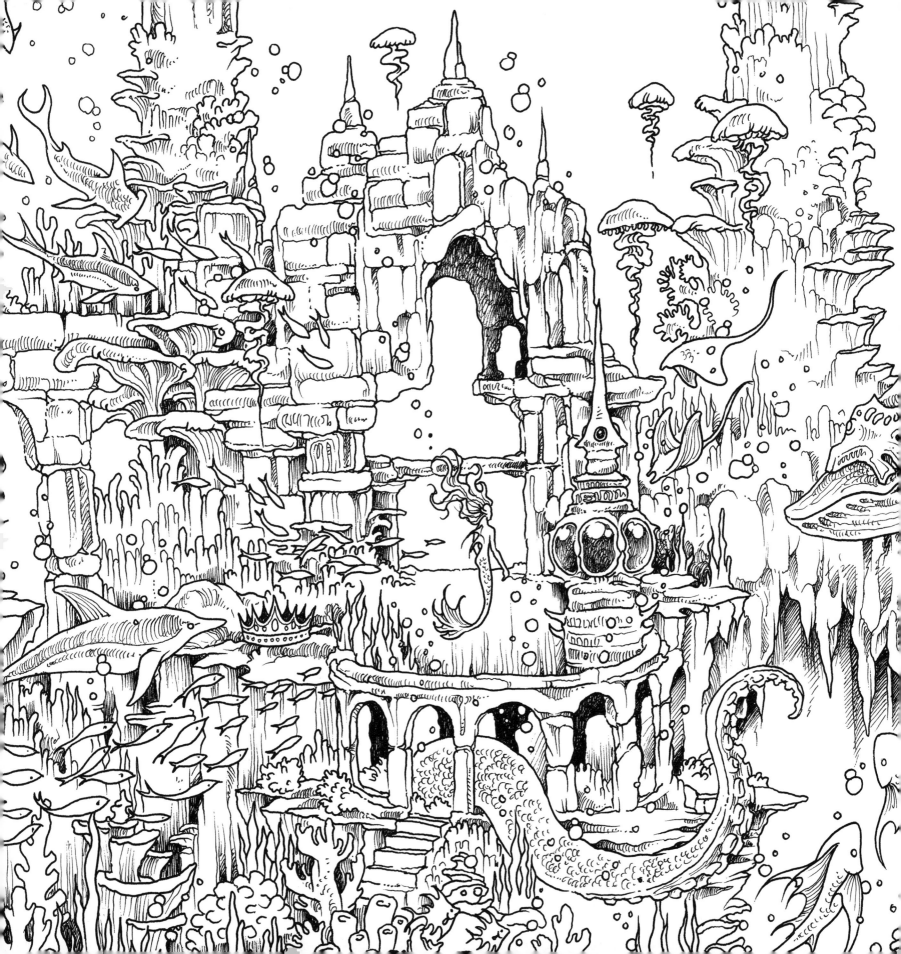

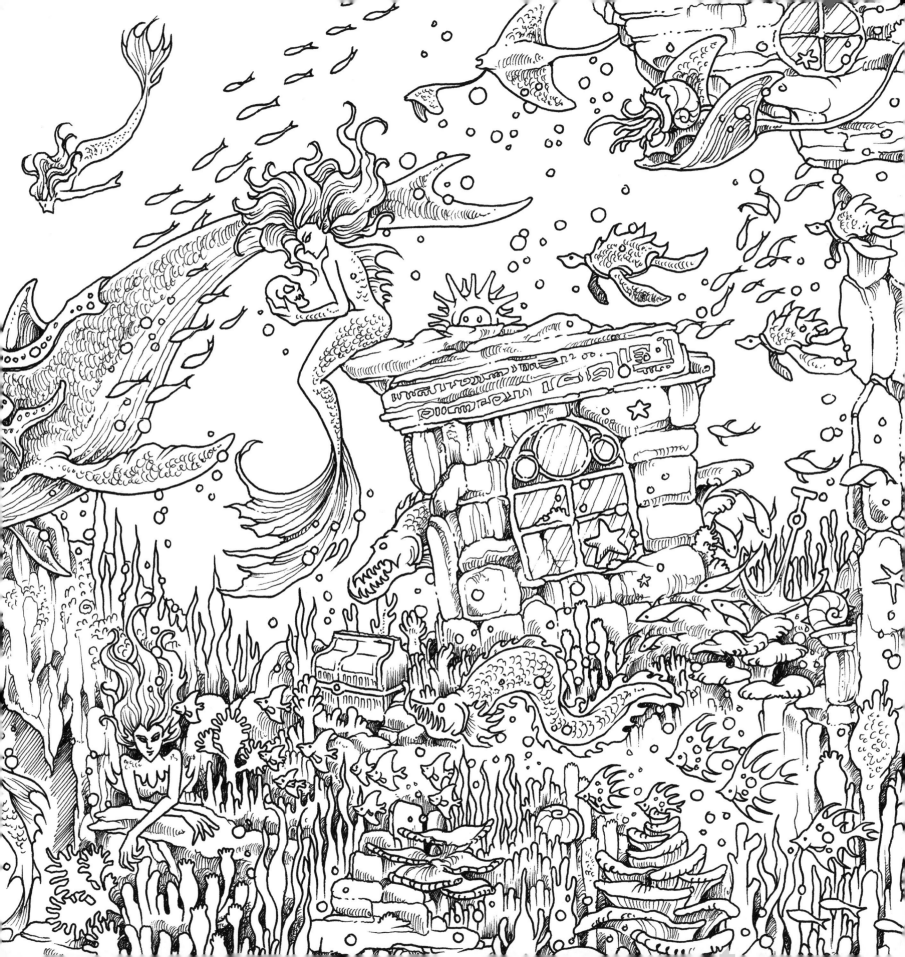

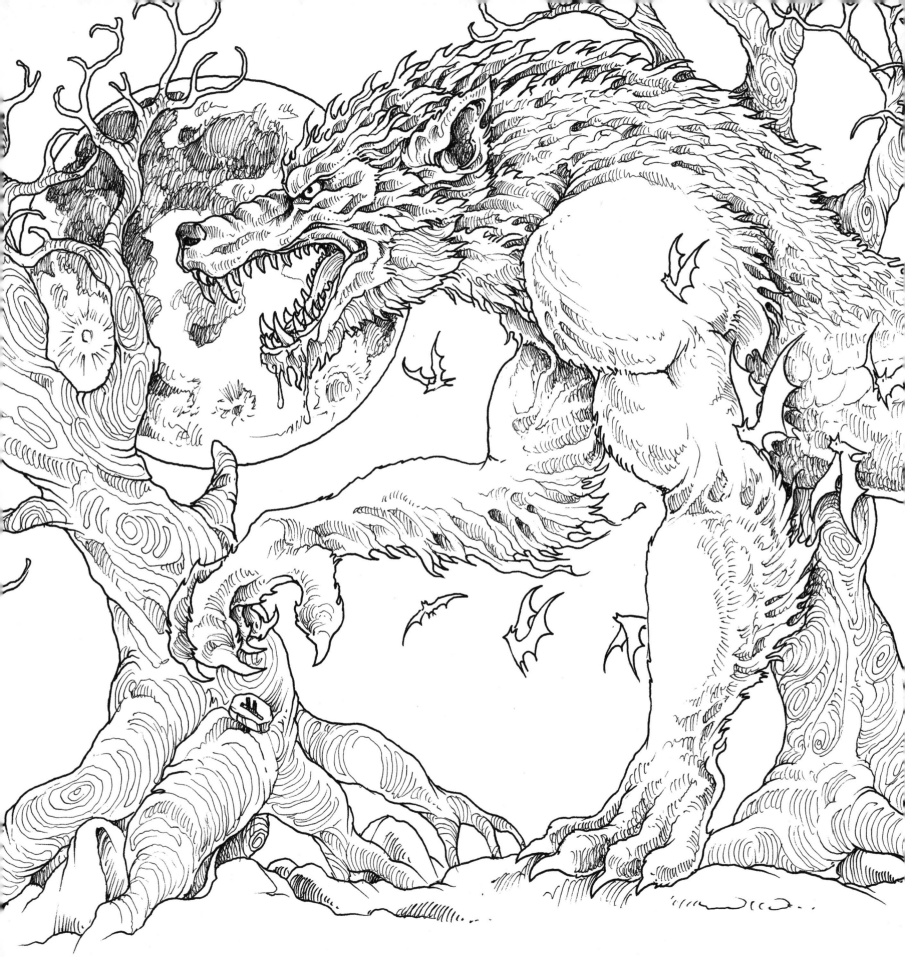

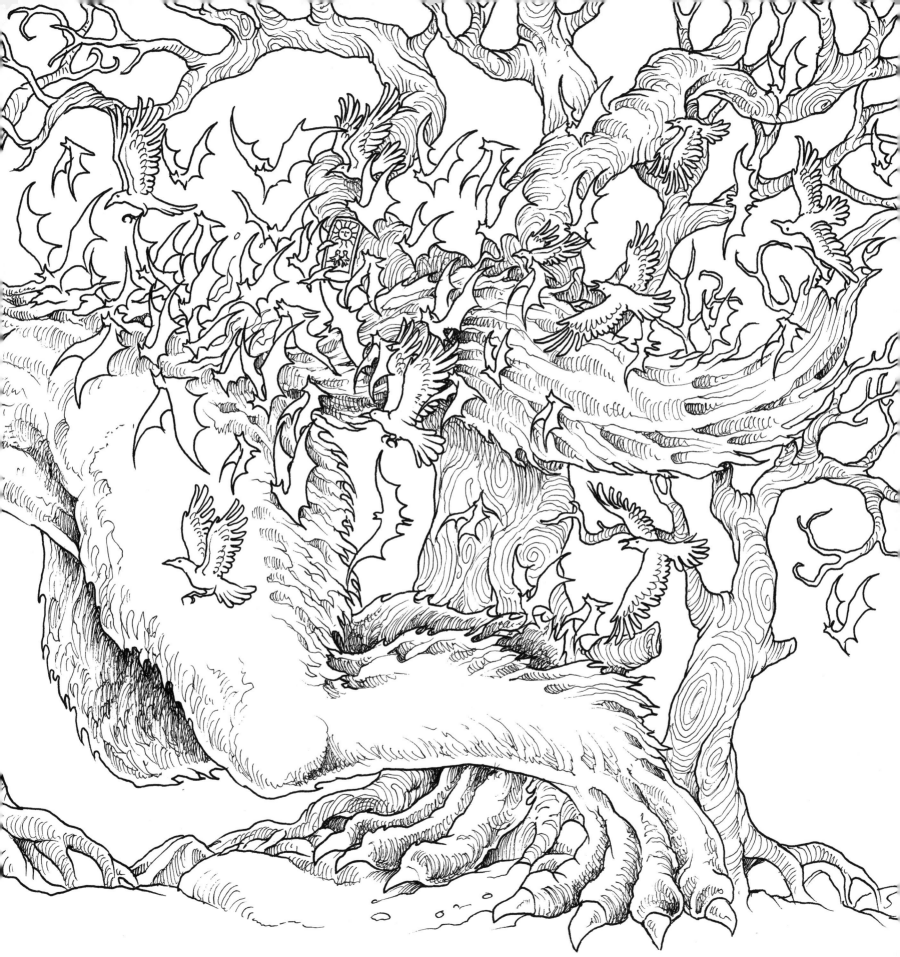

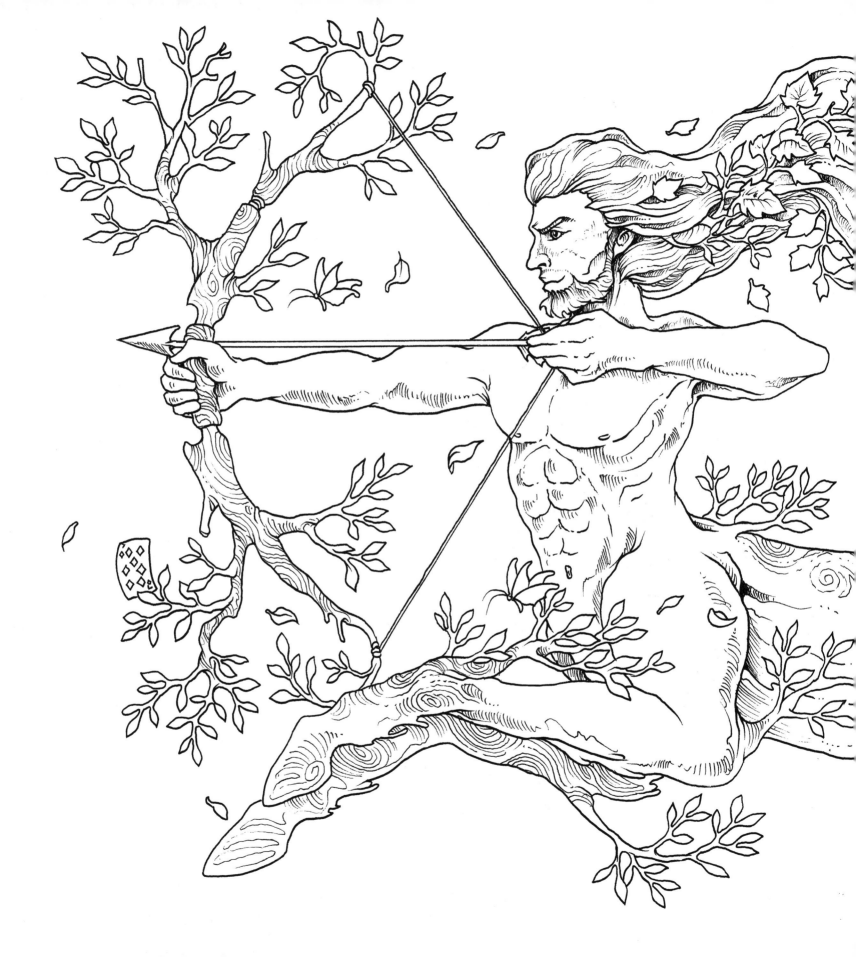

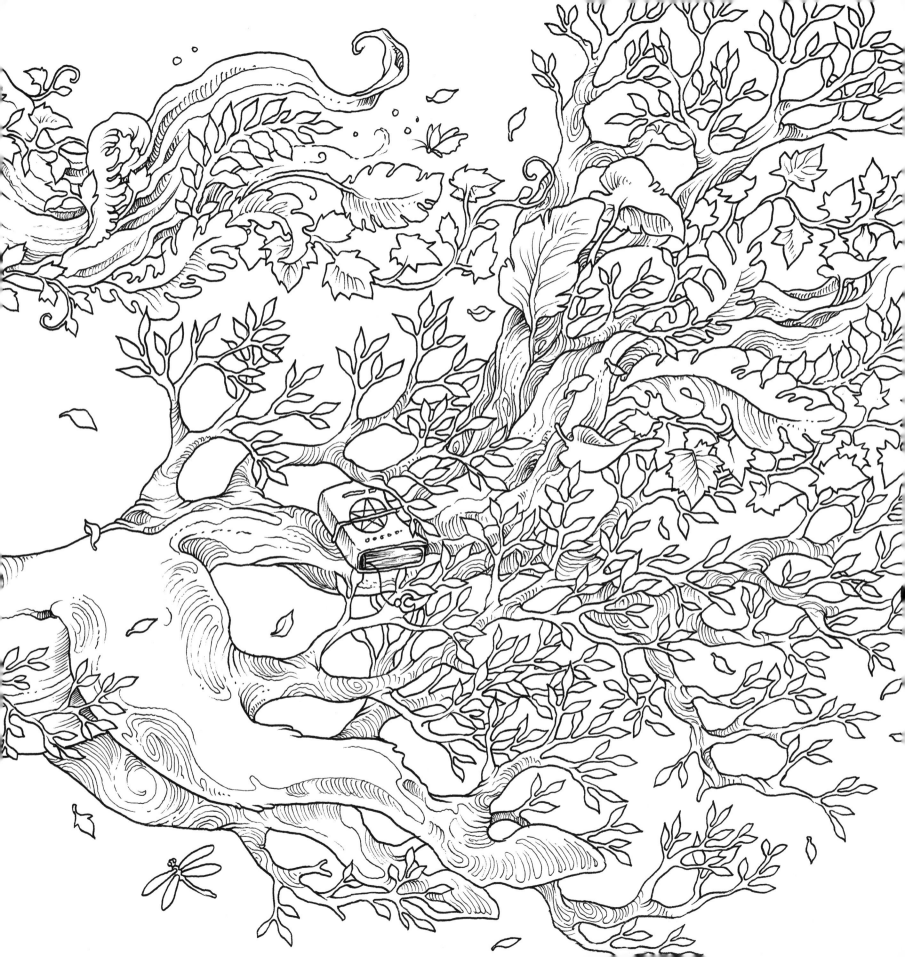

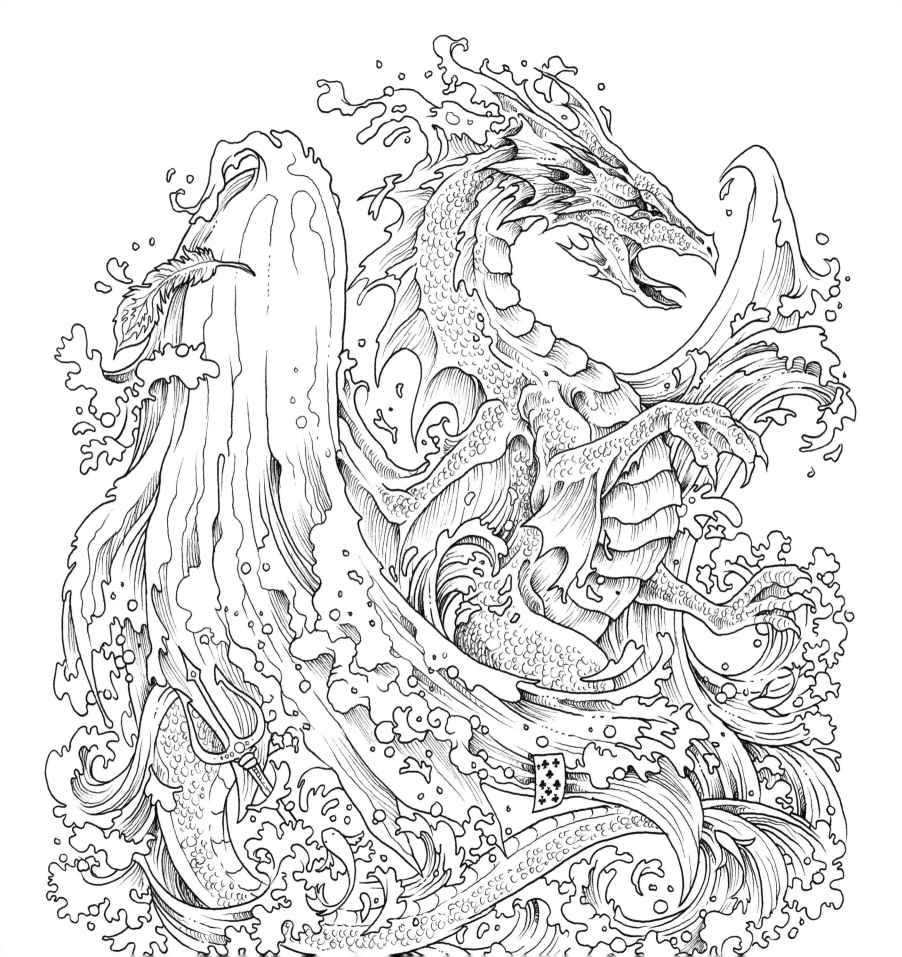

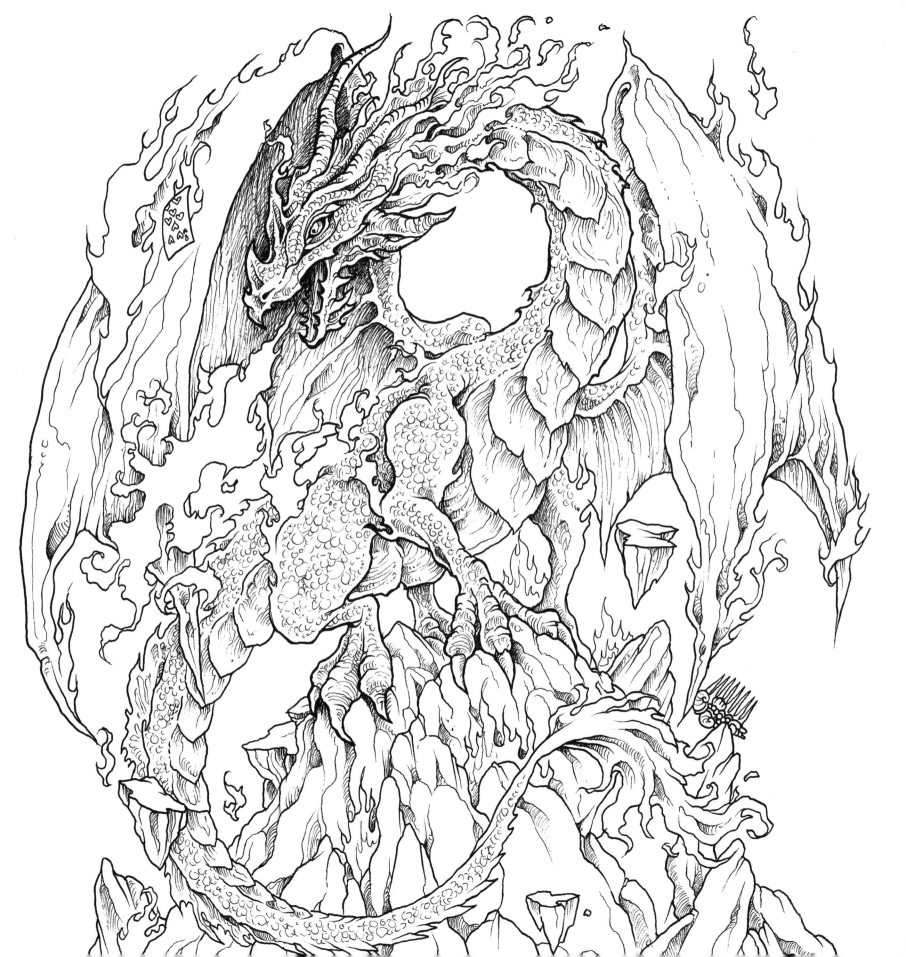

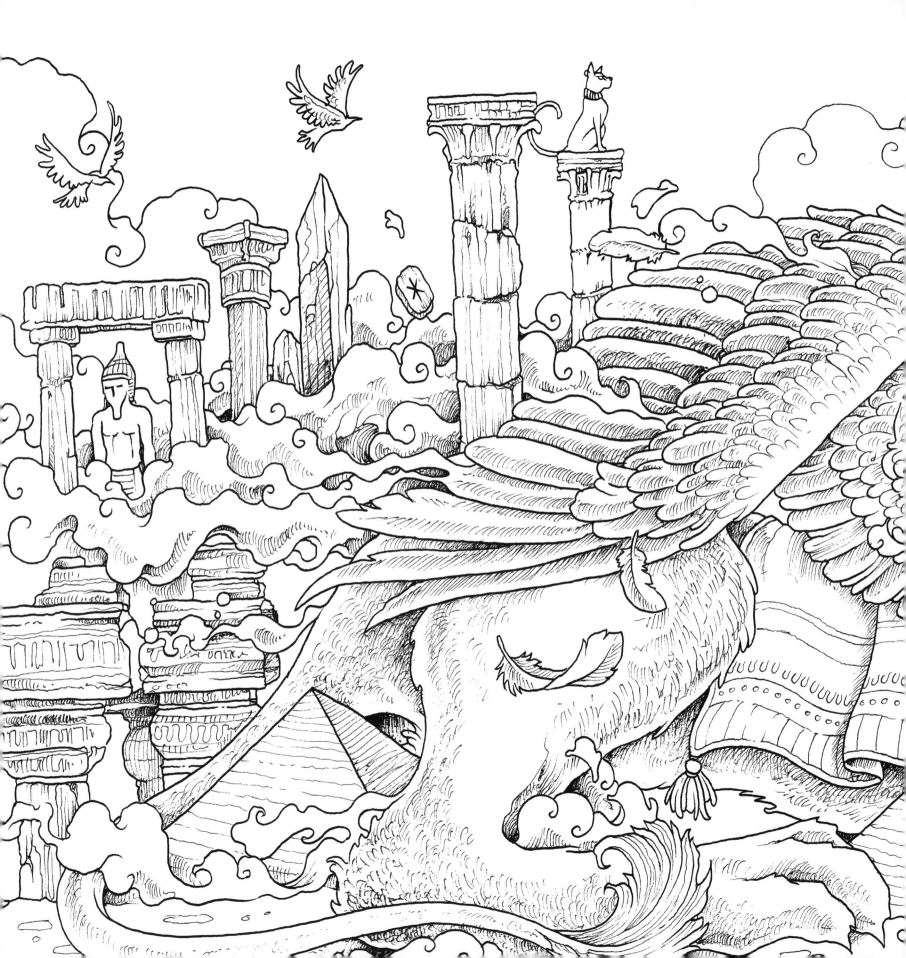

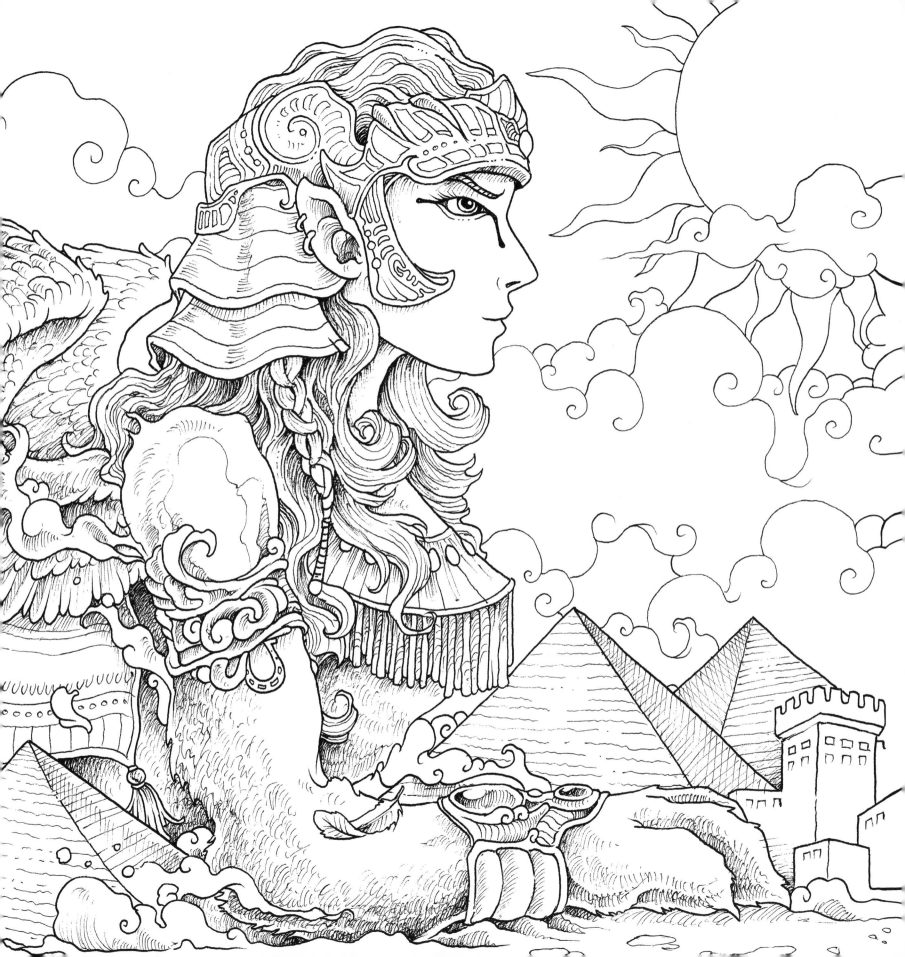

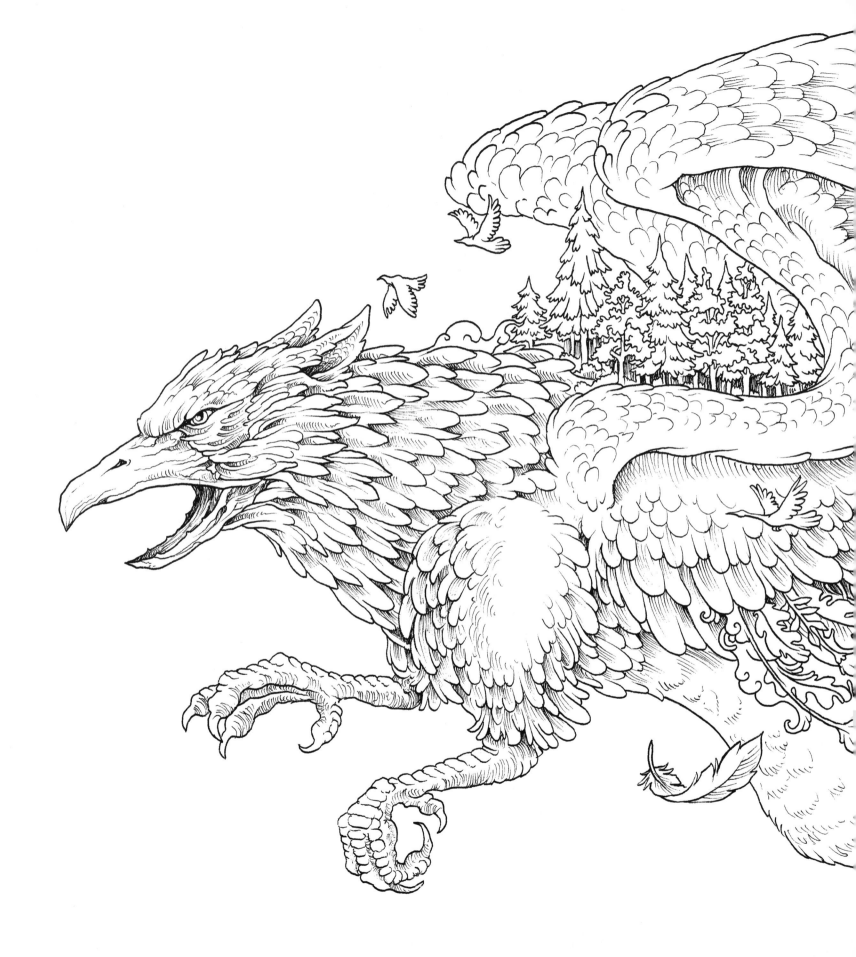

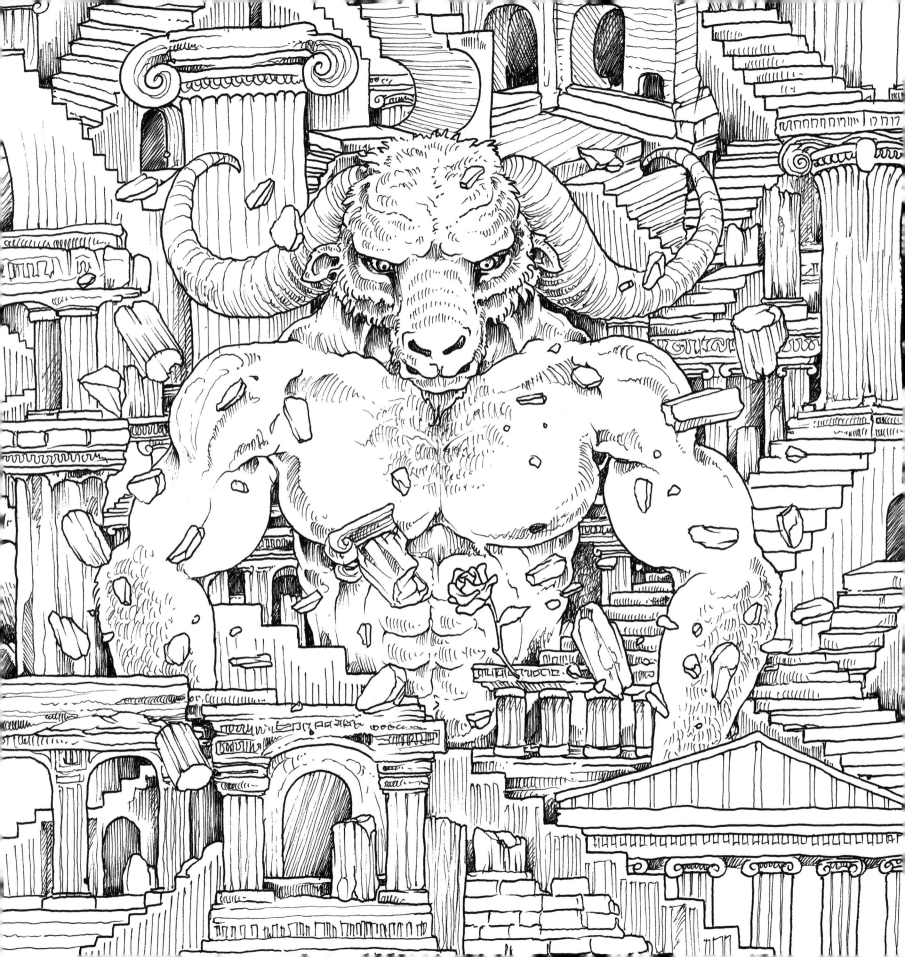

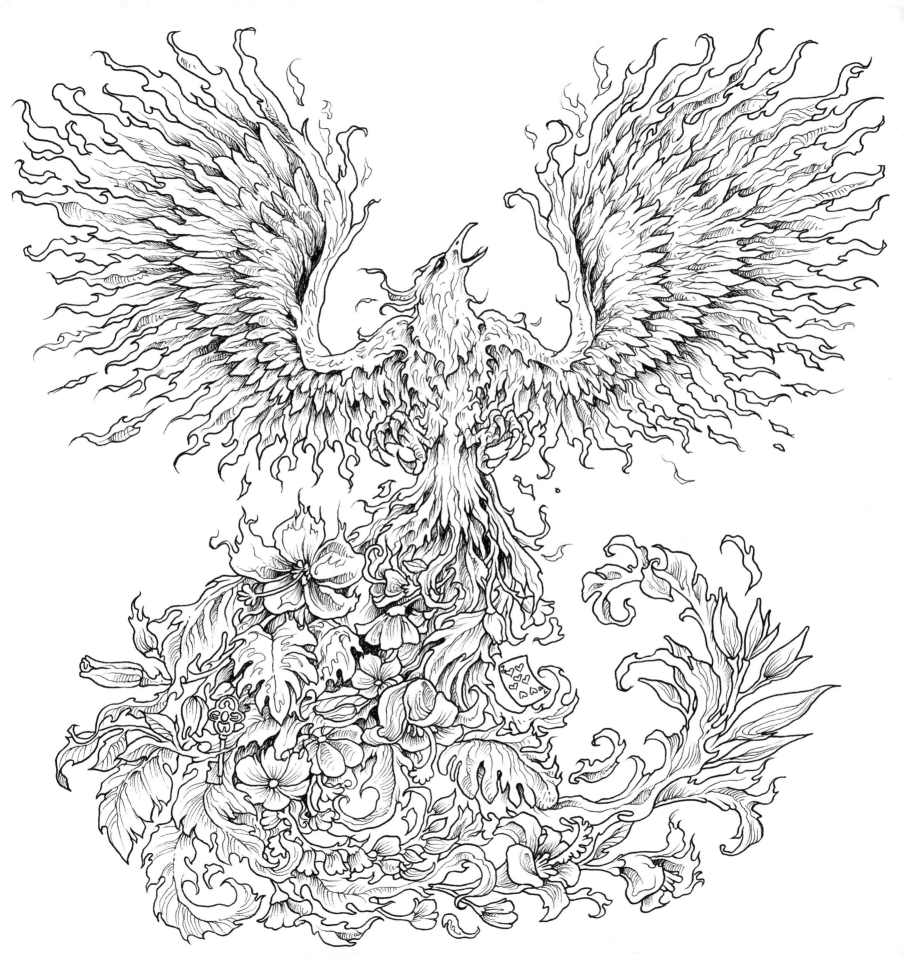

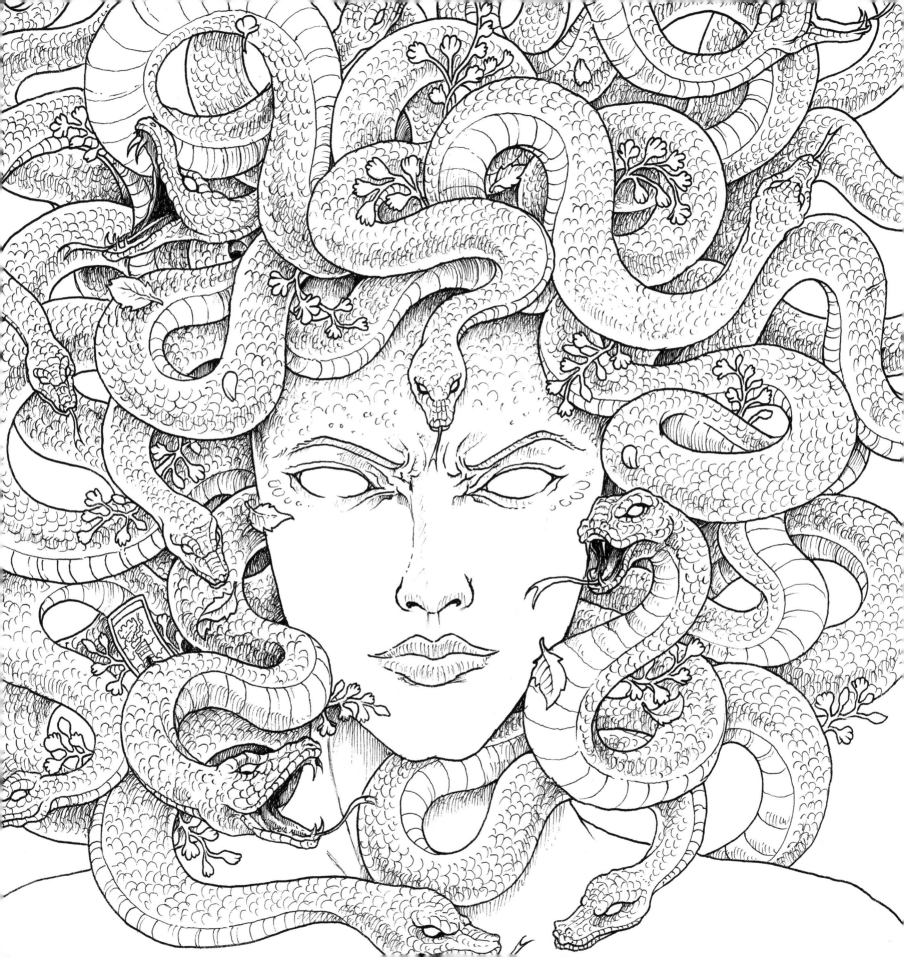

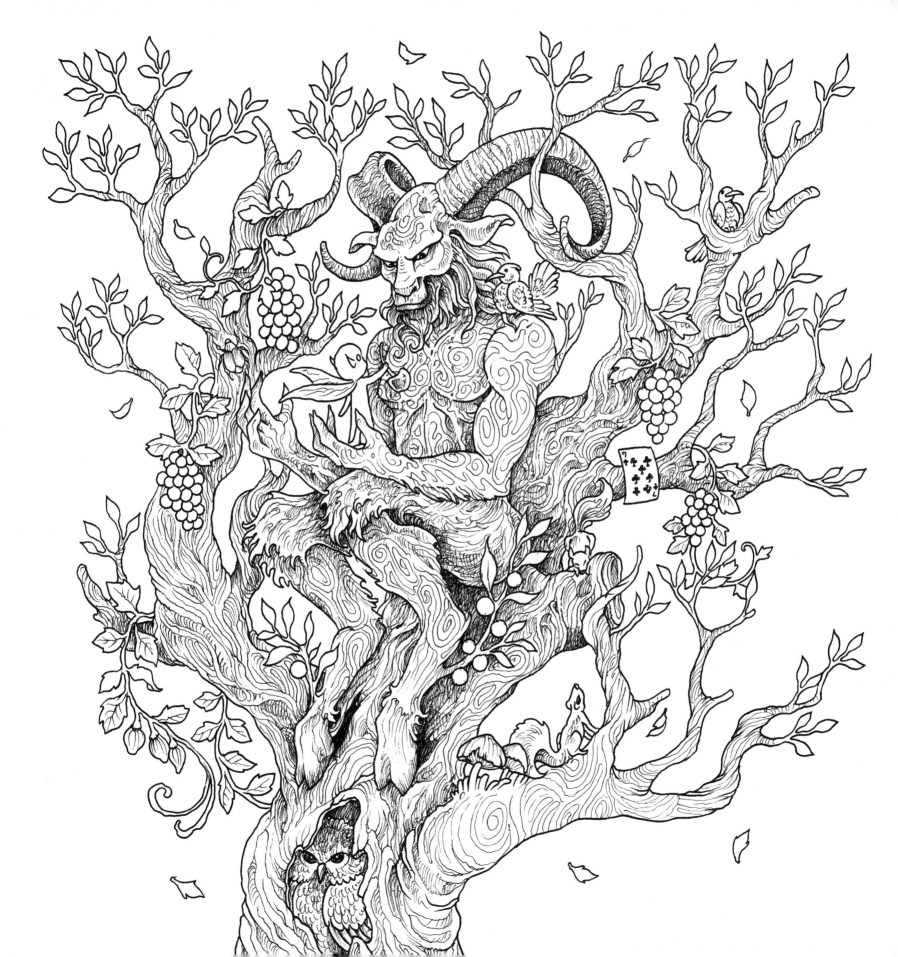

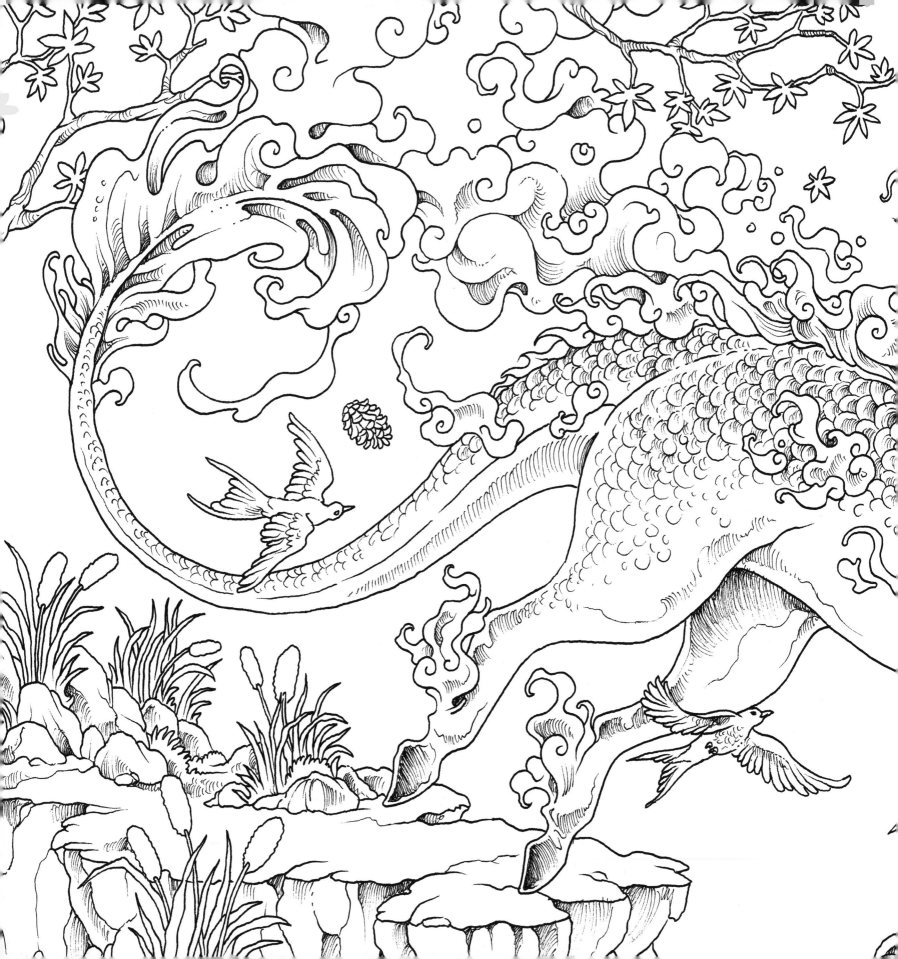

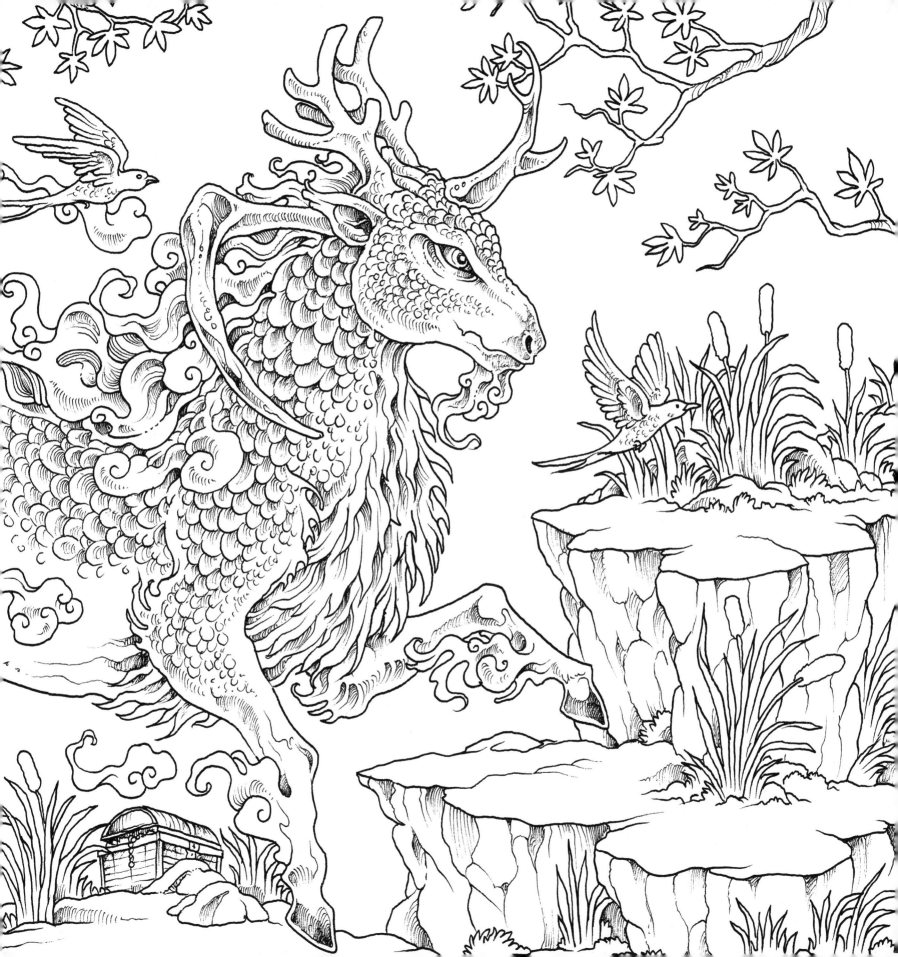

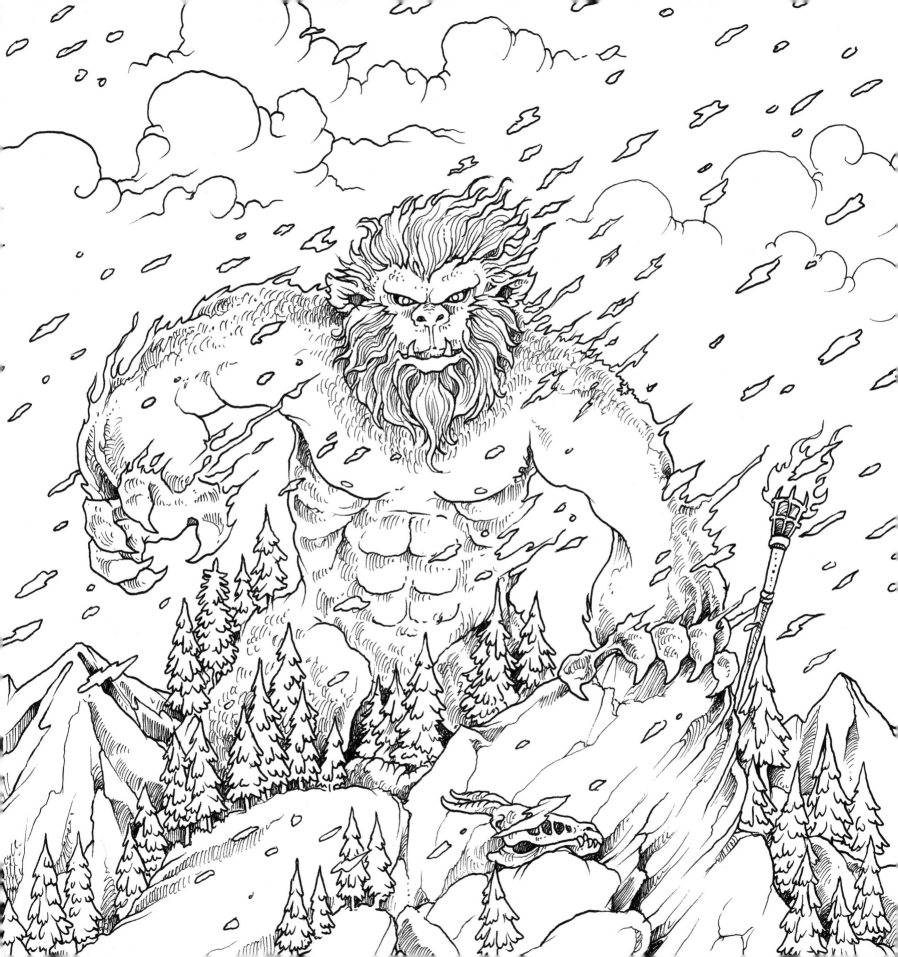

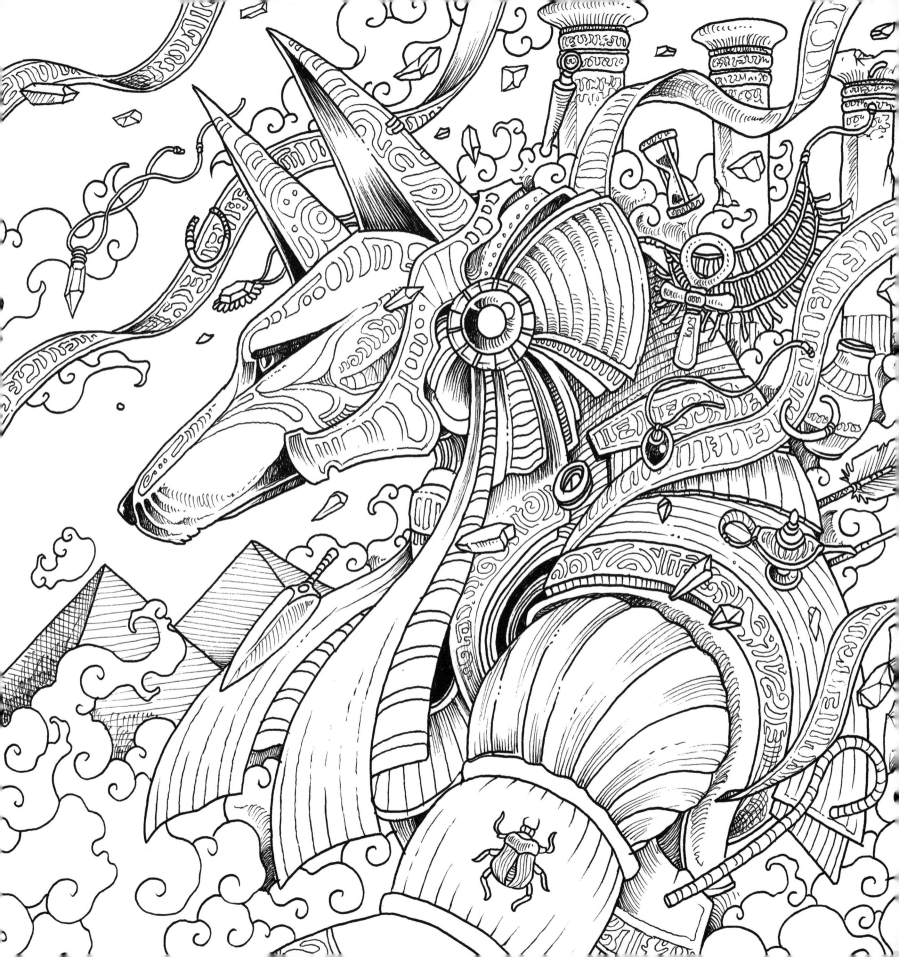

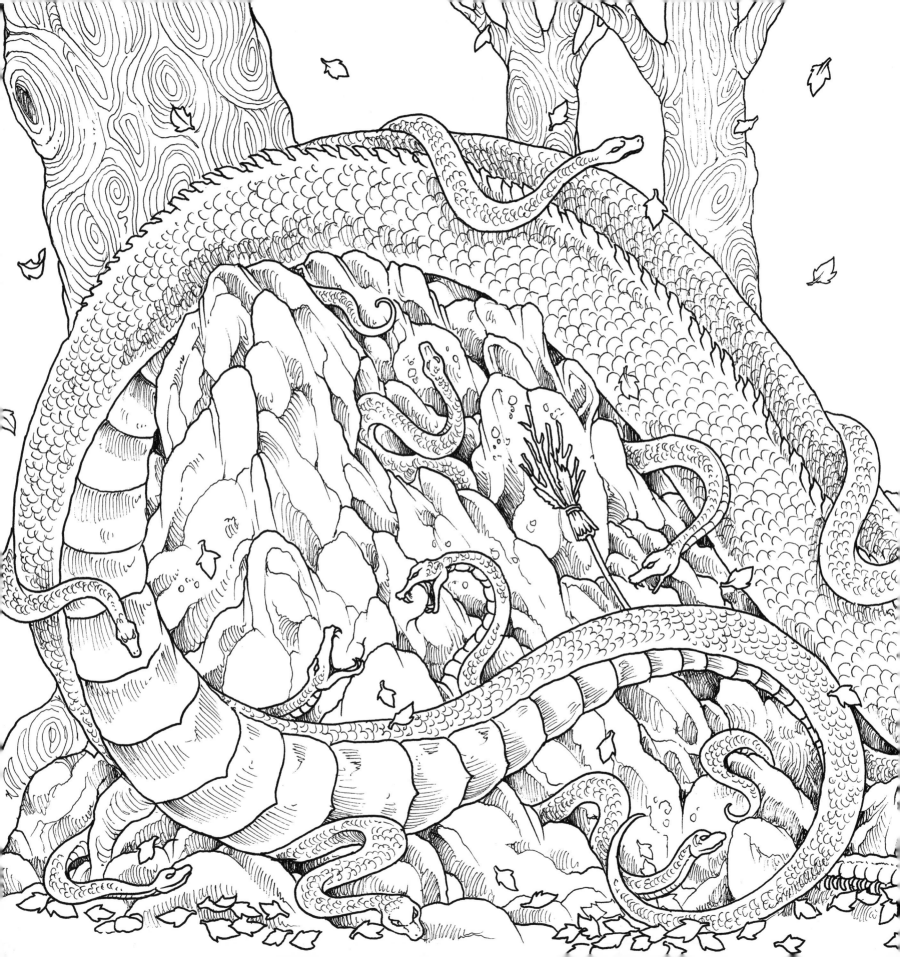

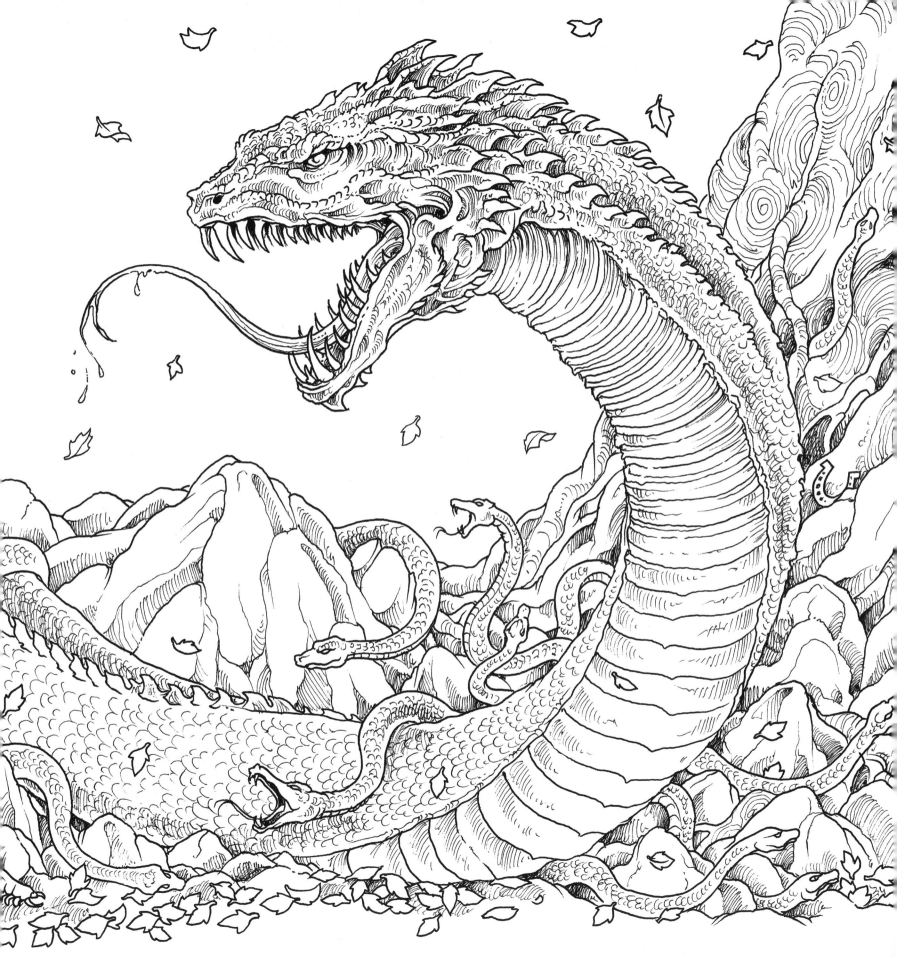

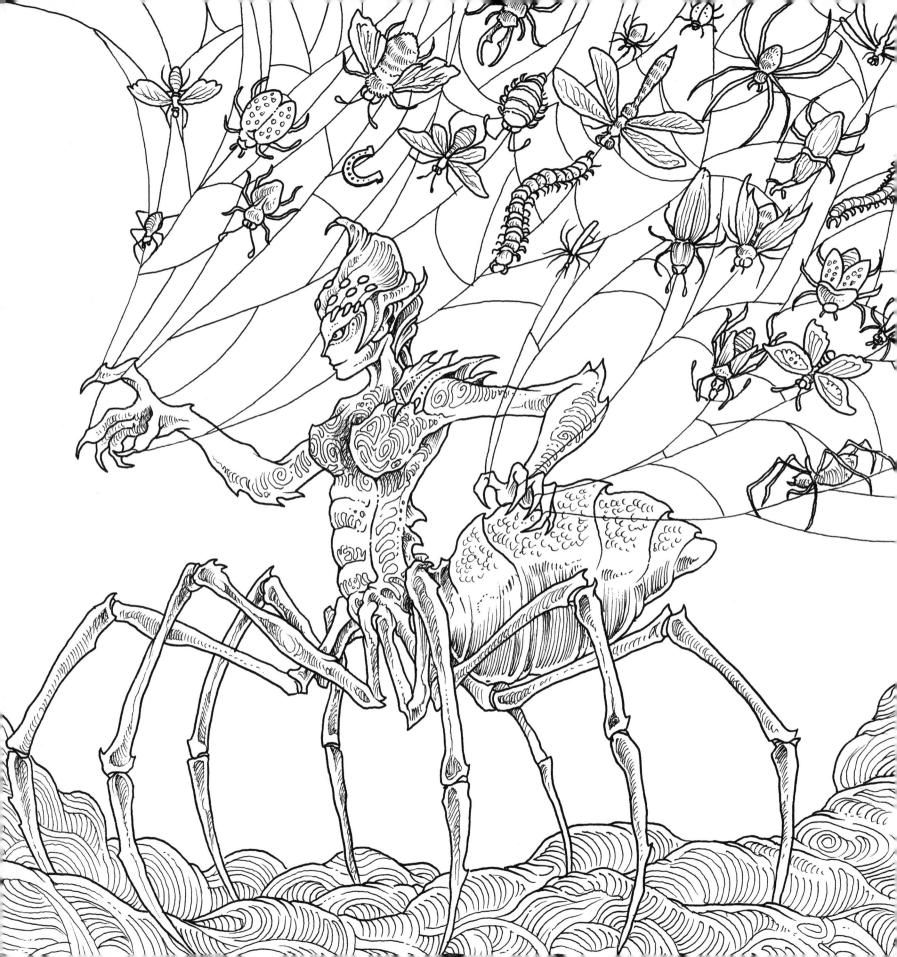

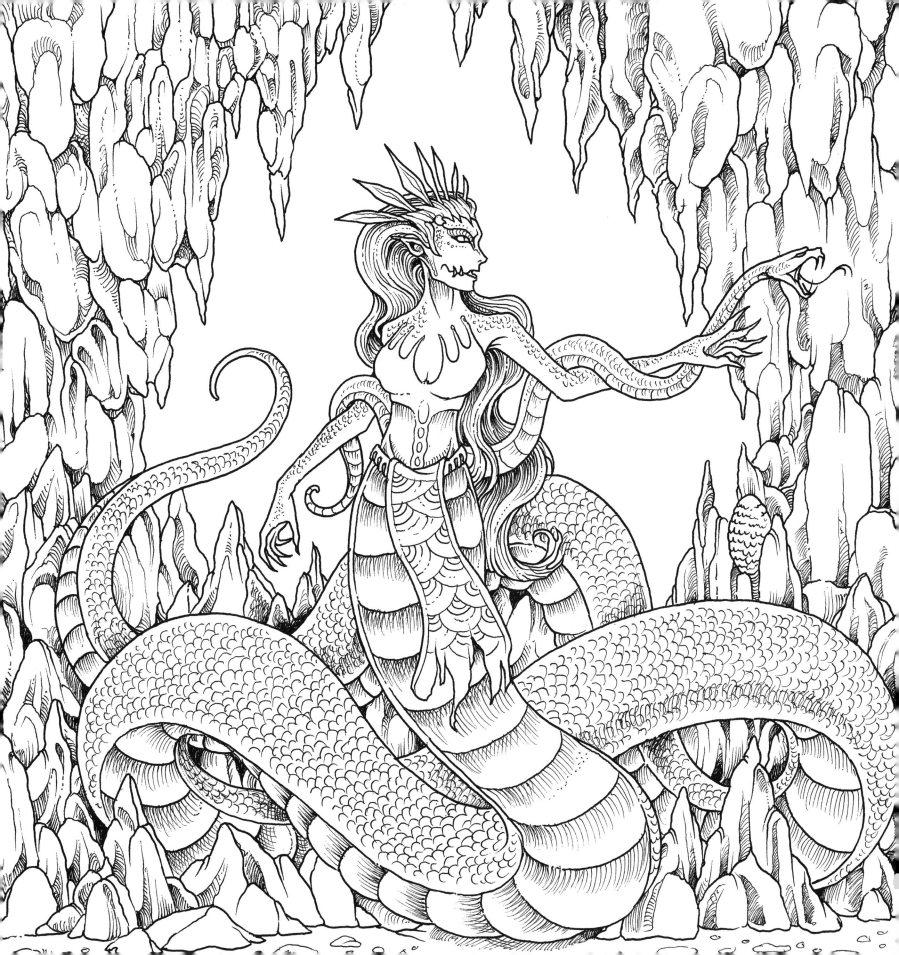

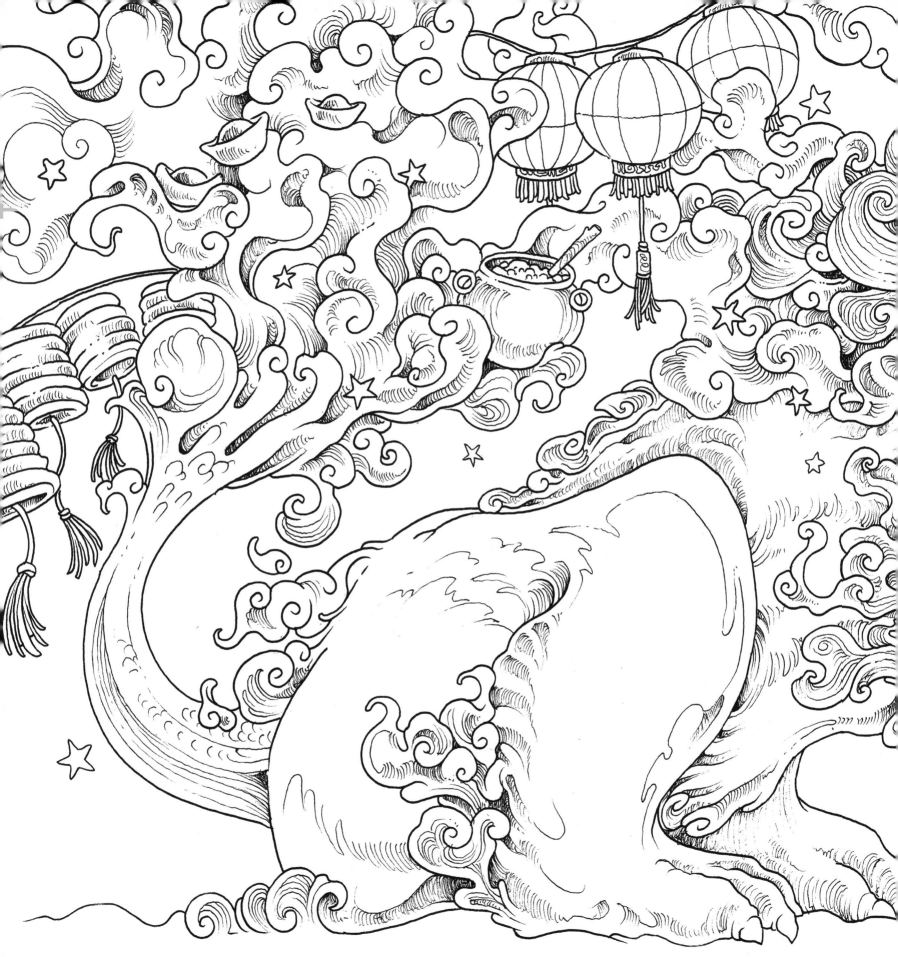

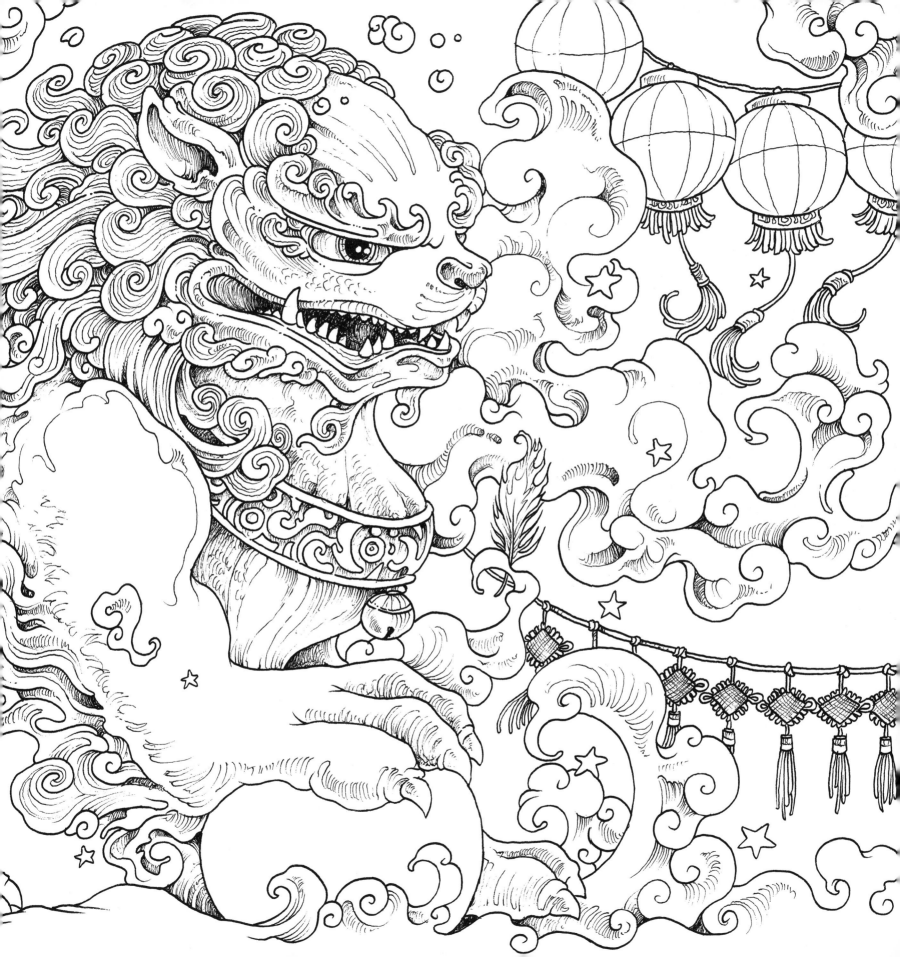

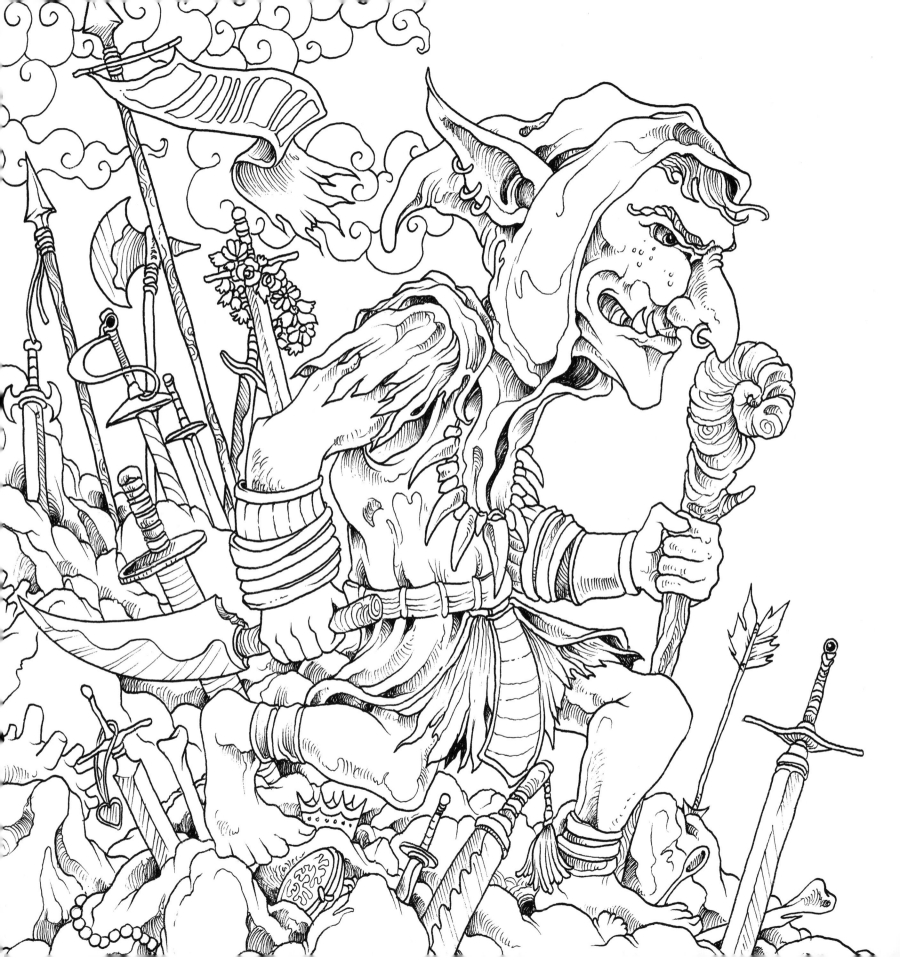

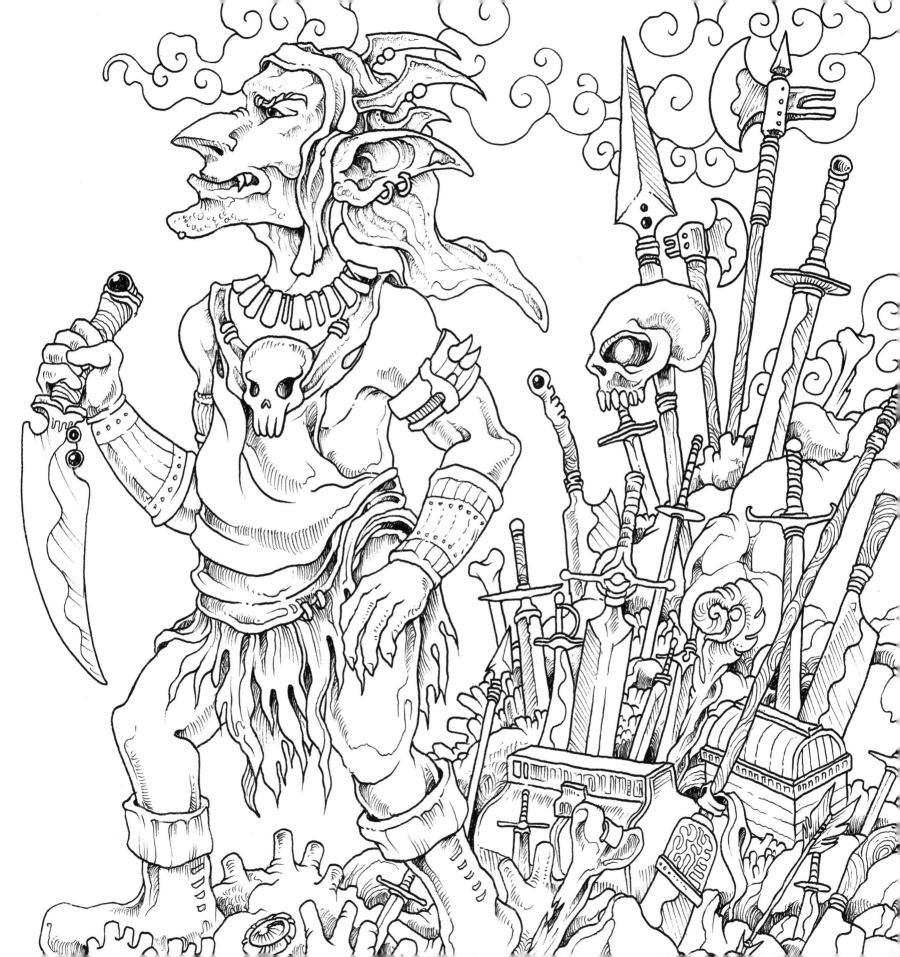

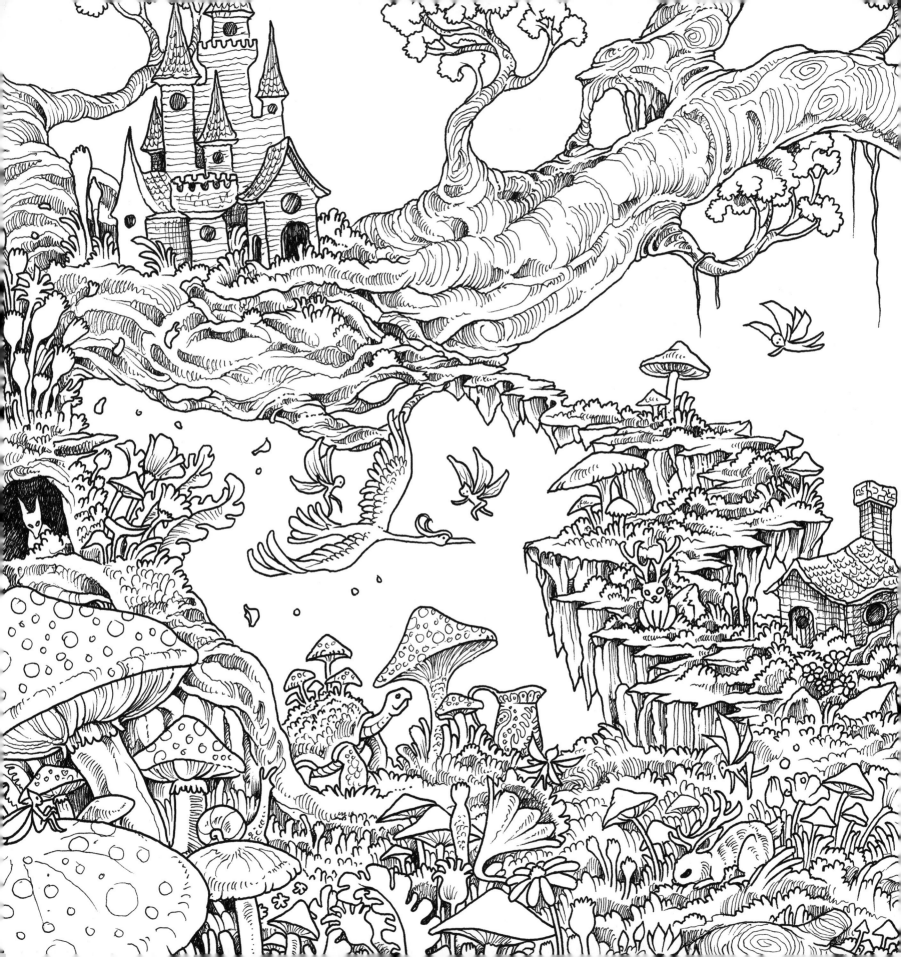

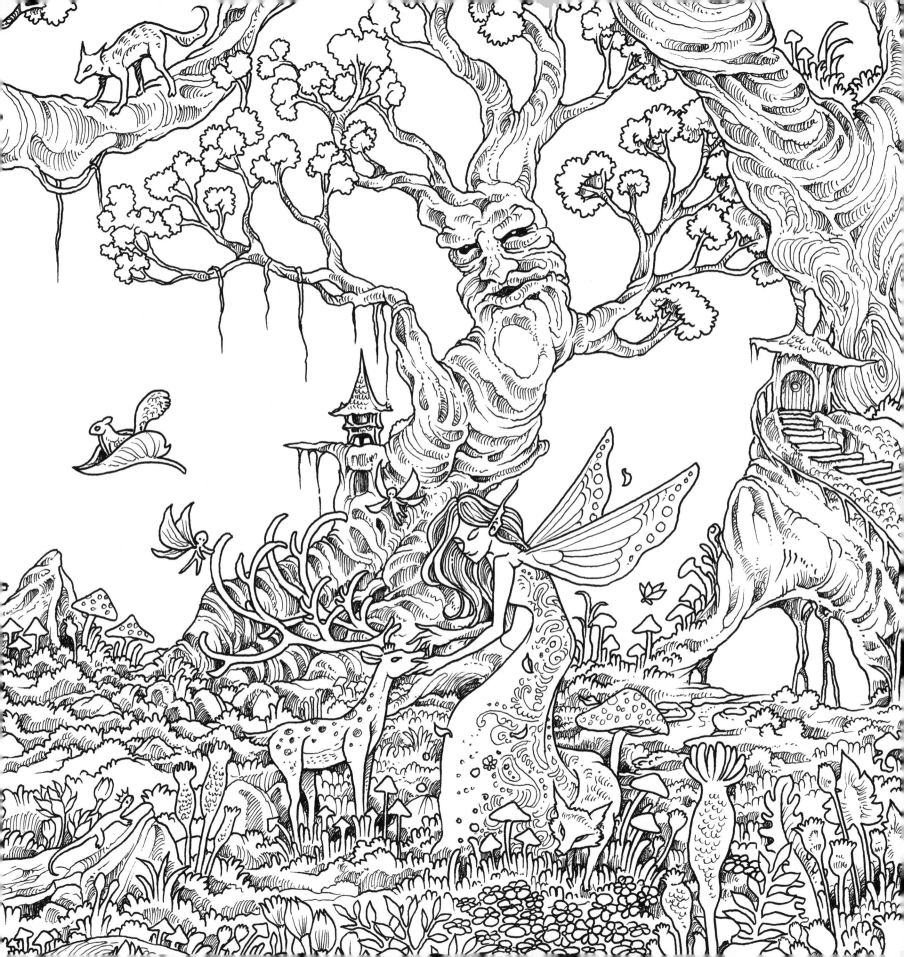

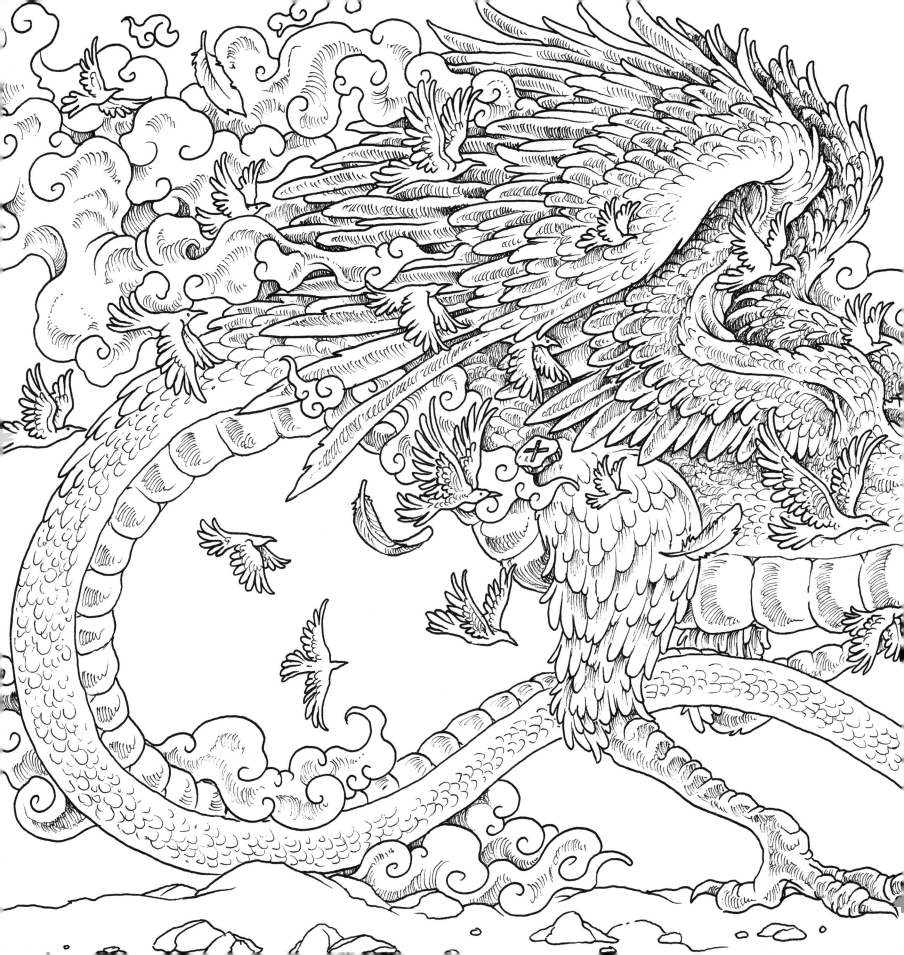

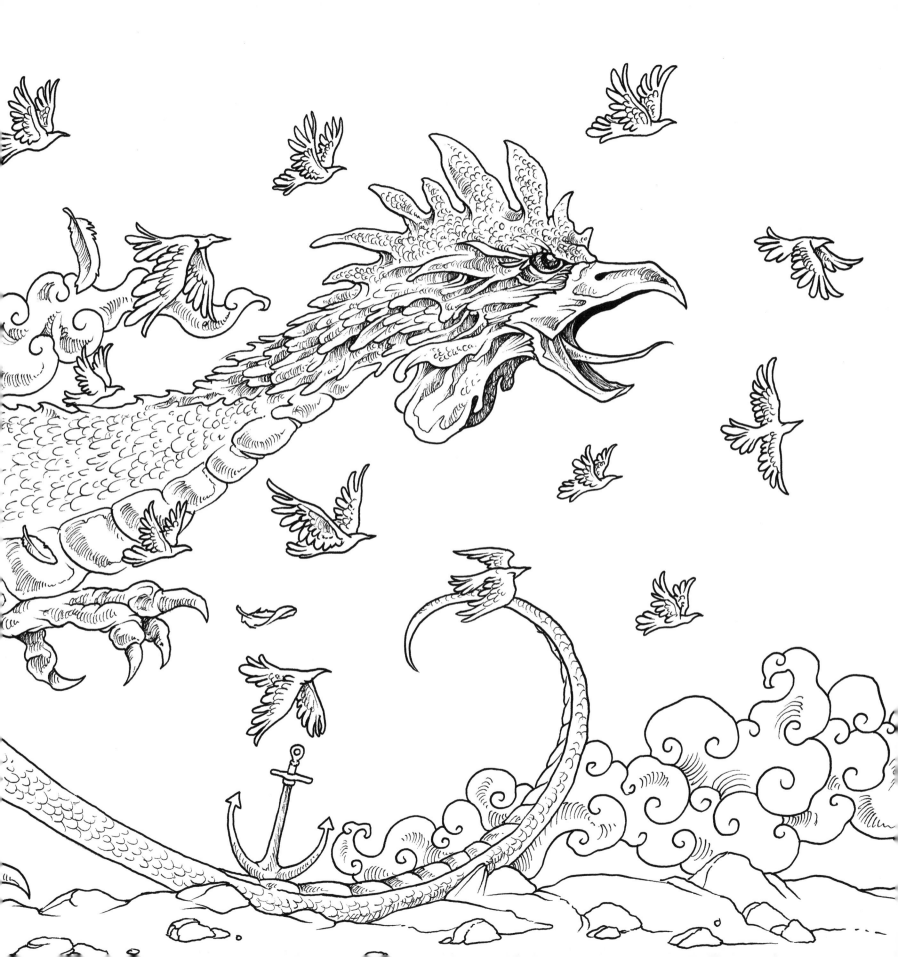

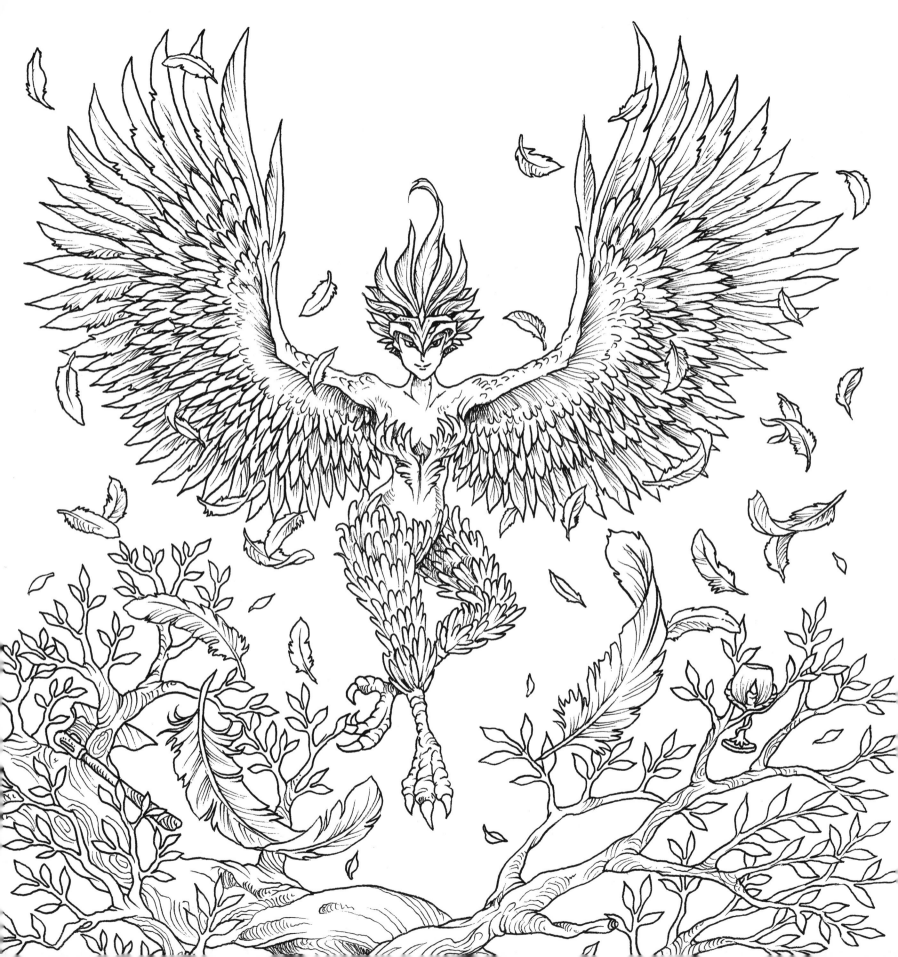

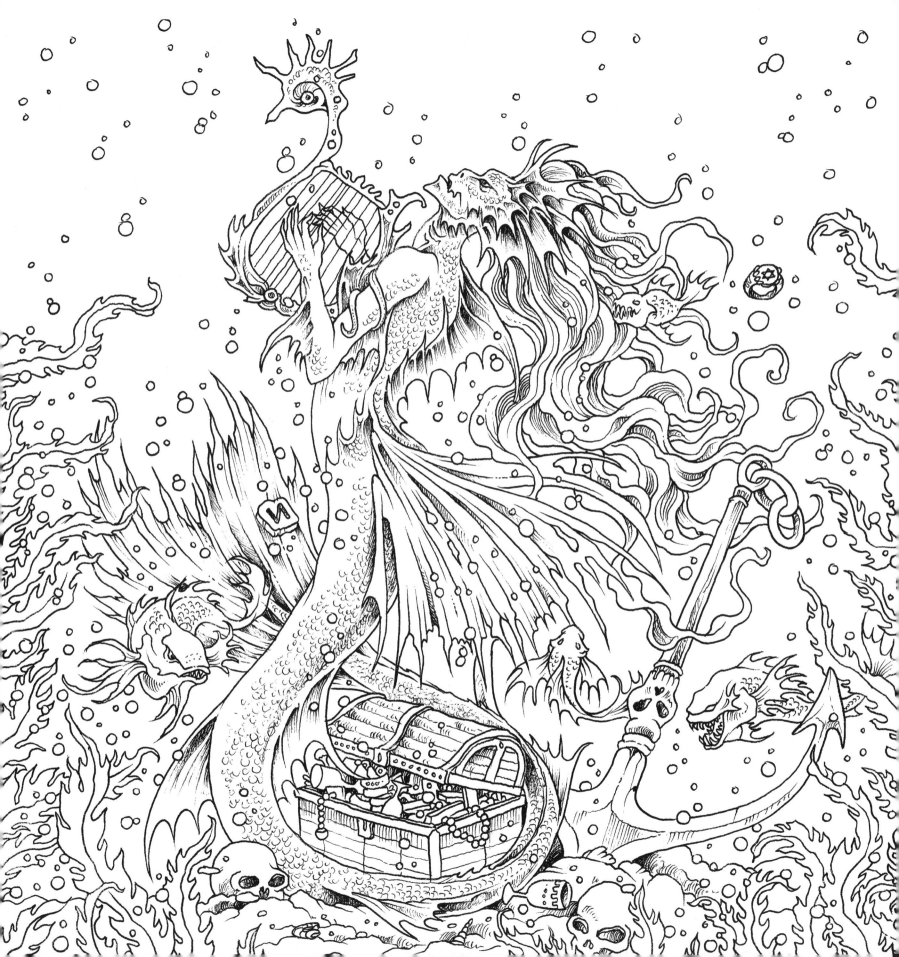

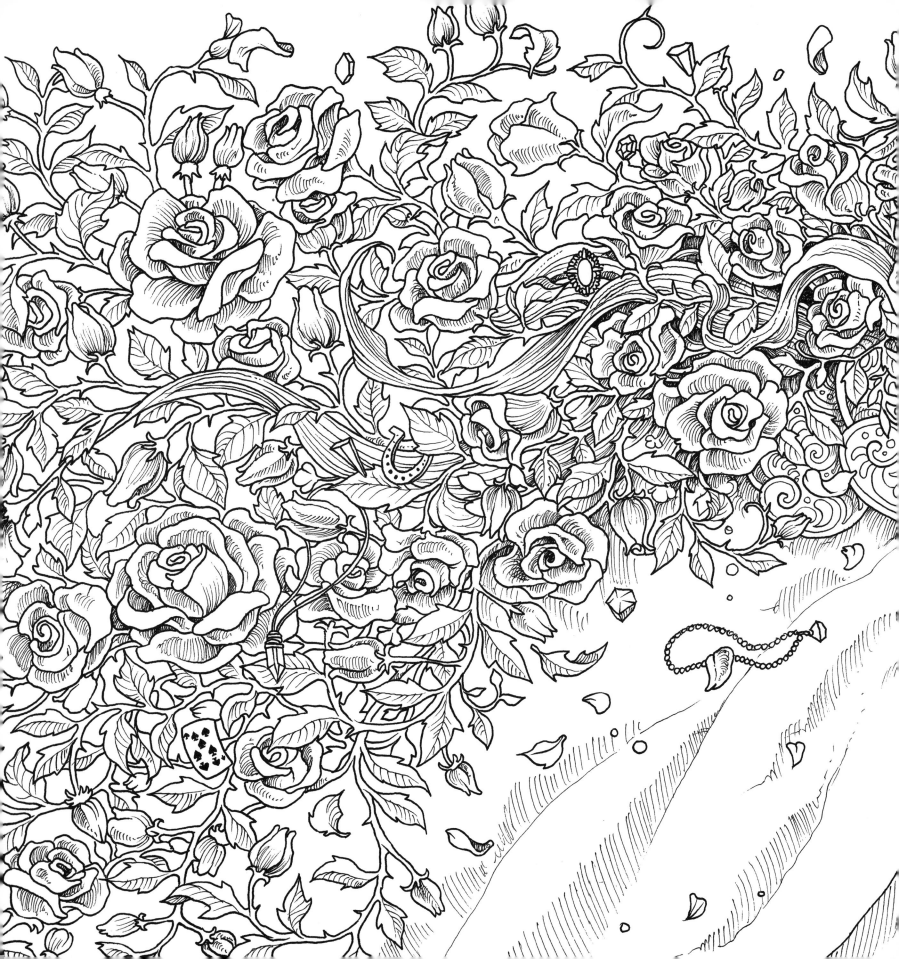

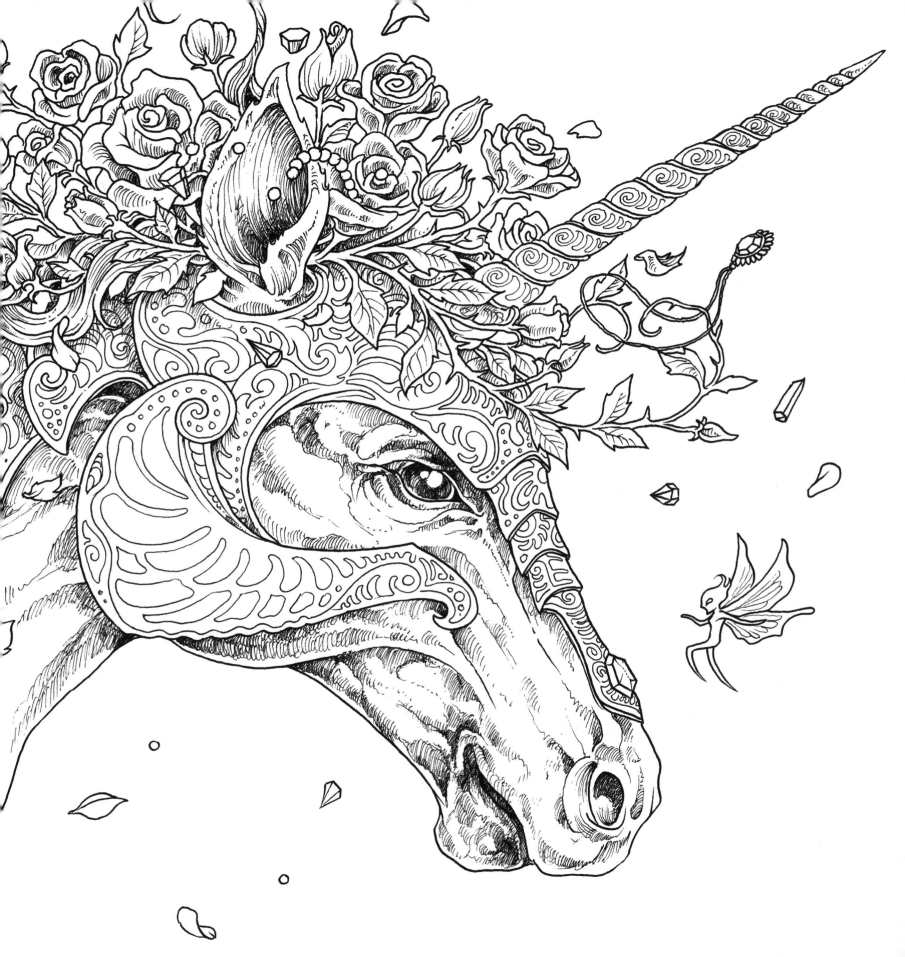

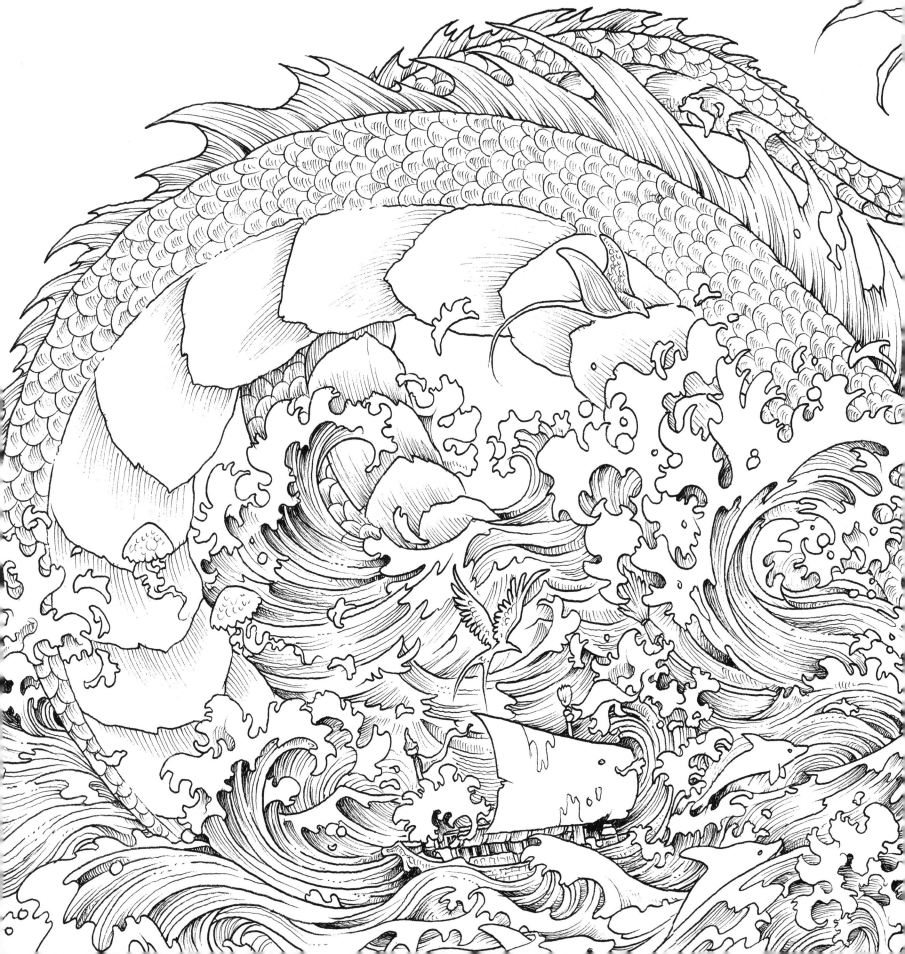

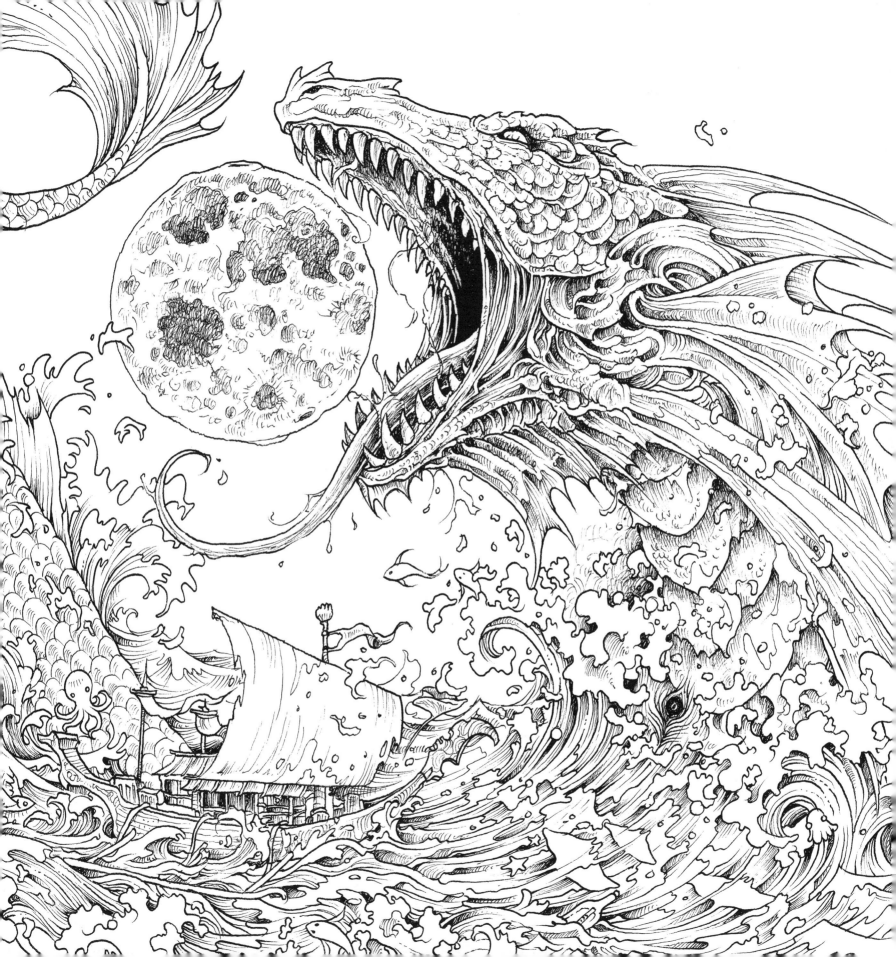

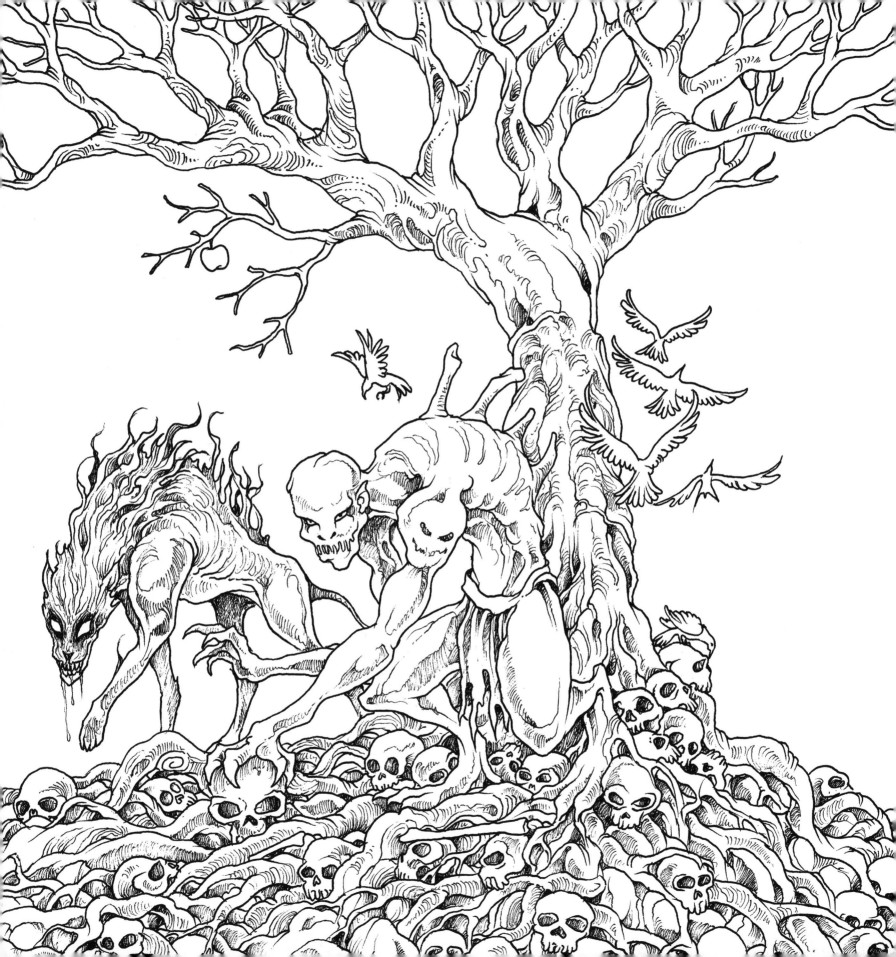

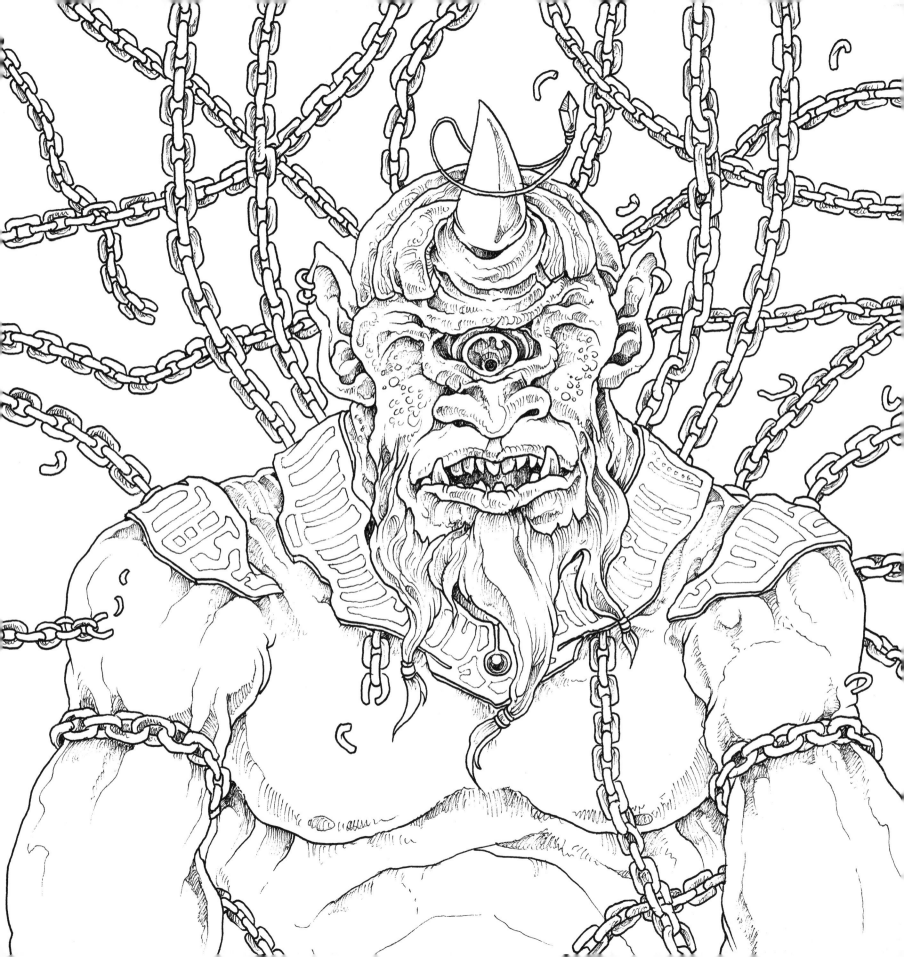

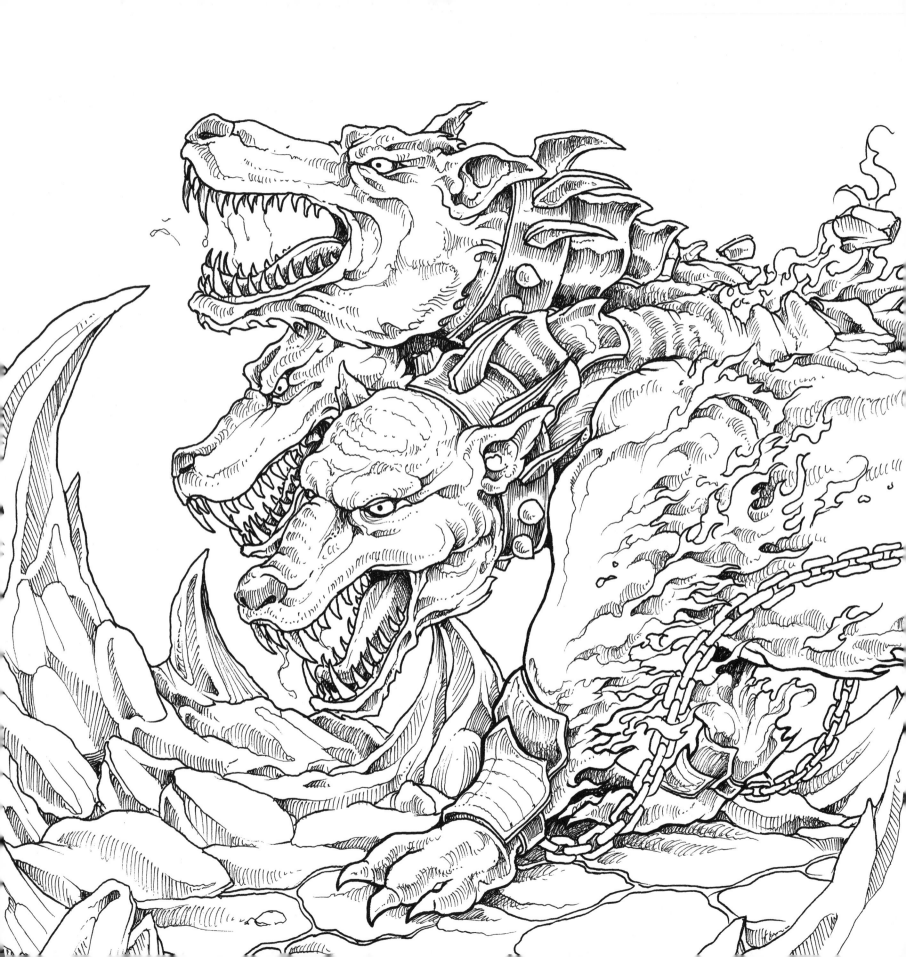

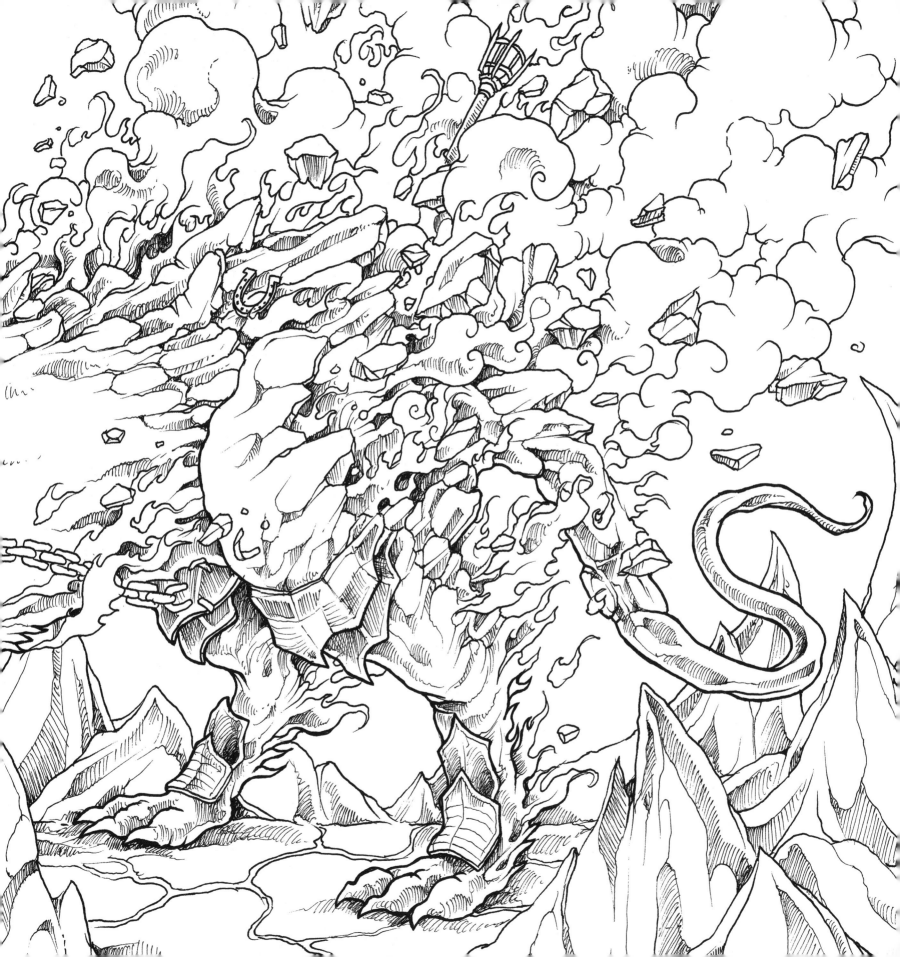

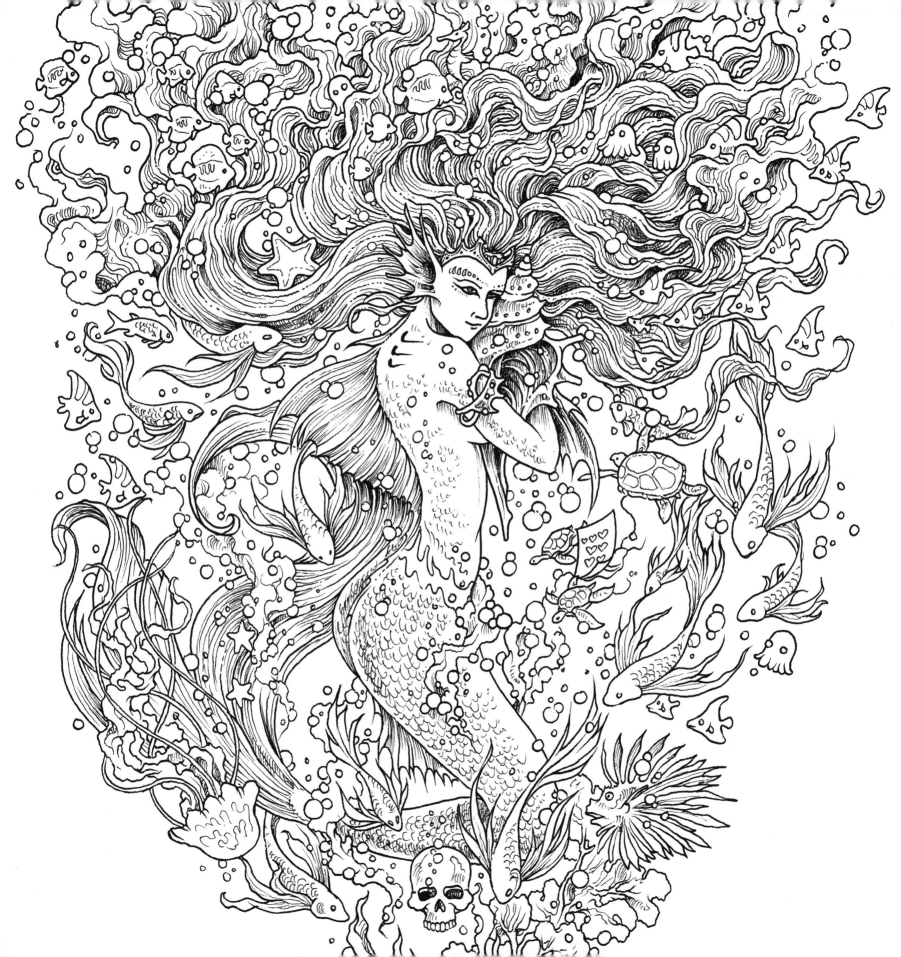

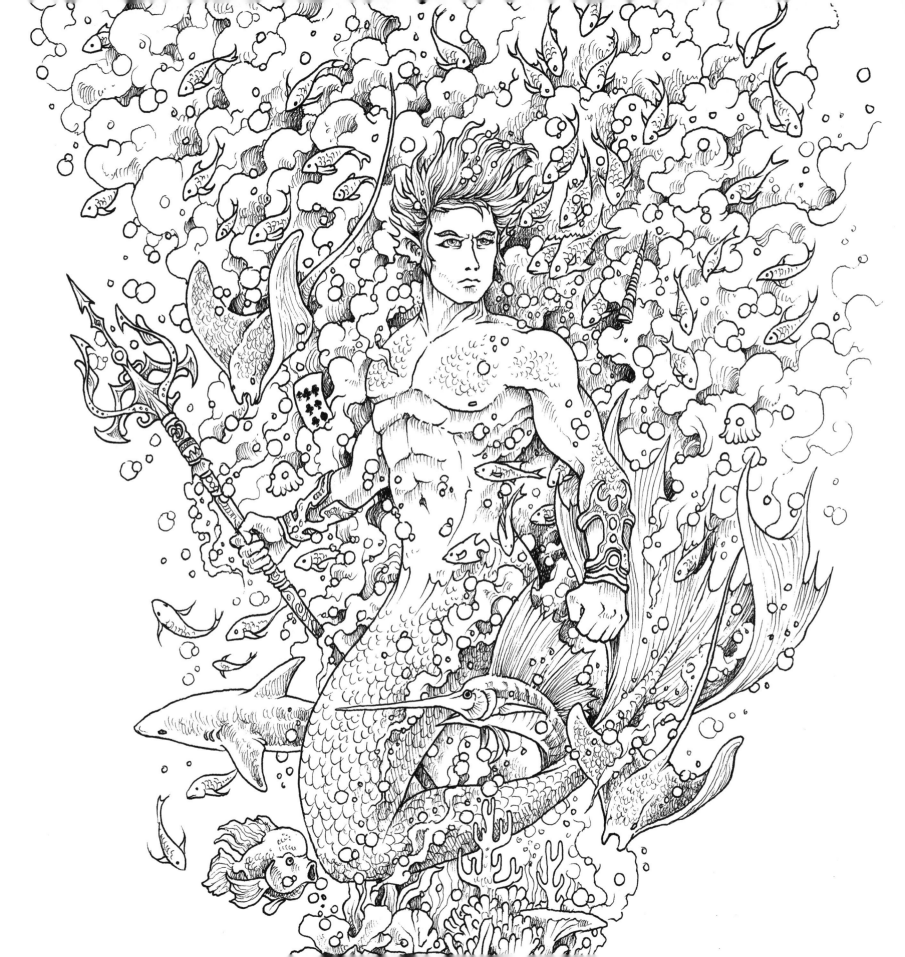

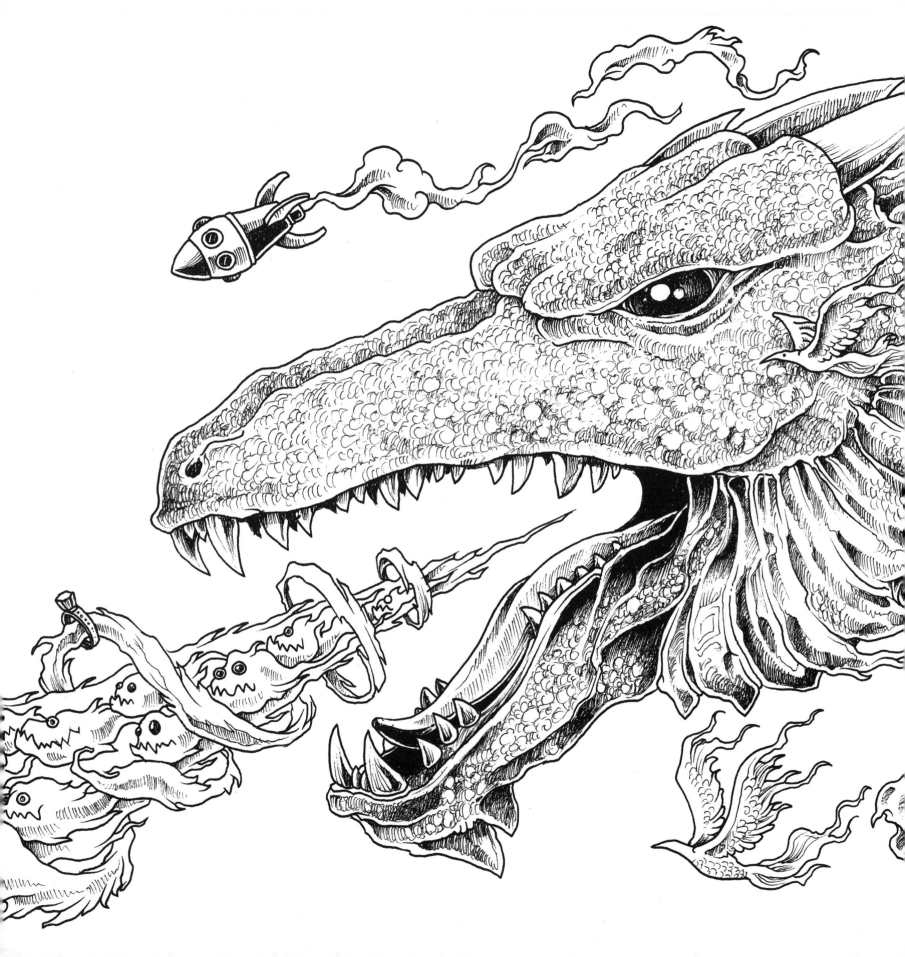

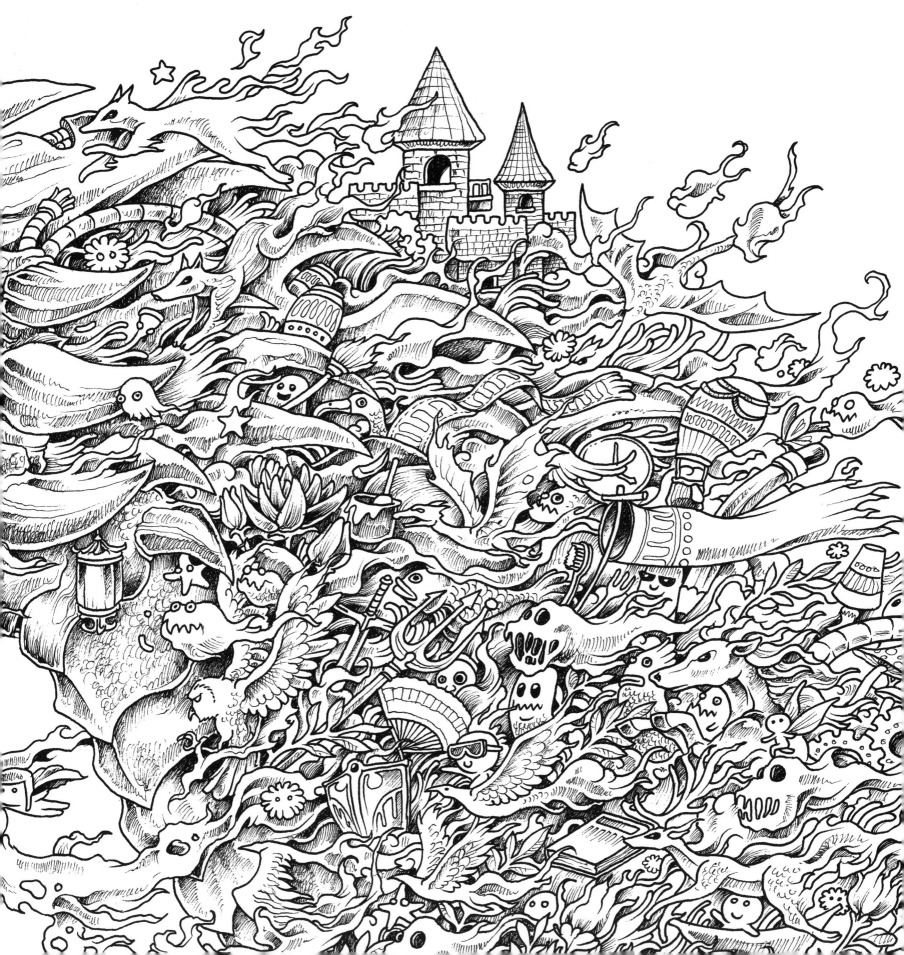

Can you find these items, artifacts, and creatures in the book?

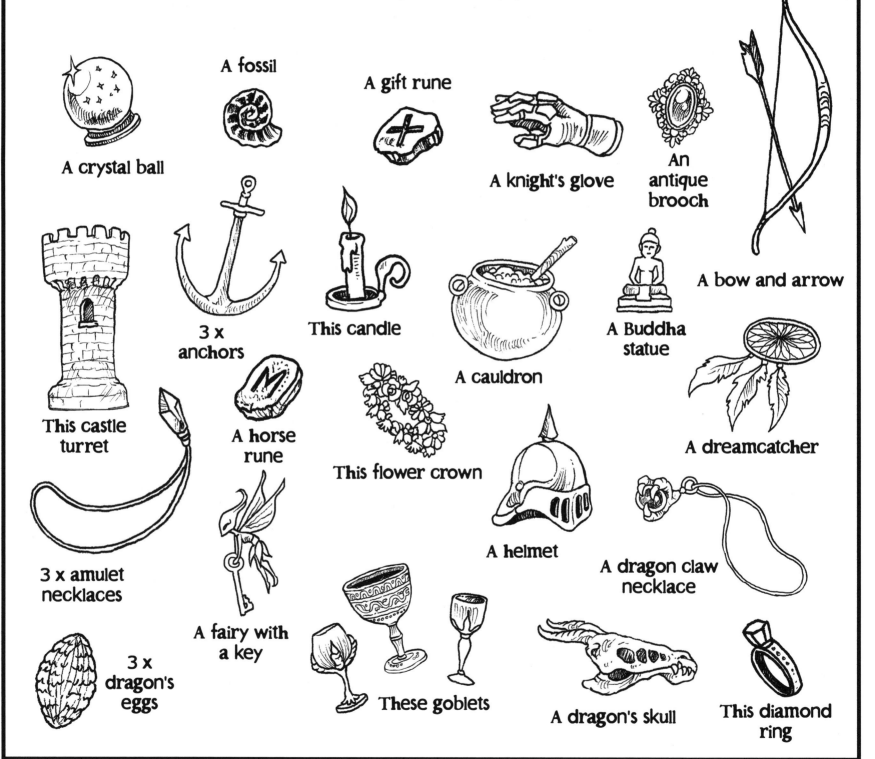

A crystal ball

A fossil

A gift rune

A knight's glove

An antique brooch

A bow and arrow

This castle turret

3 x anchors

This candle

A cauldron

A Buddha statue

A dreamcatcher

A horse rune

This flower crown

A helmet

A dragon claw necklace

3 x amulet necklaces

A fairy with a key

These goblets

A dragon's skull

This diamond ring

3 x dragon's eggs

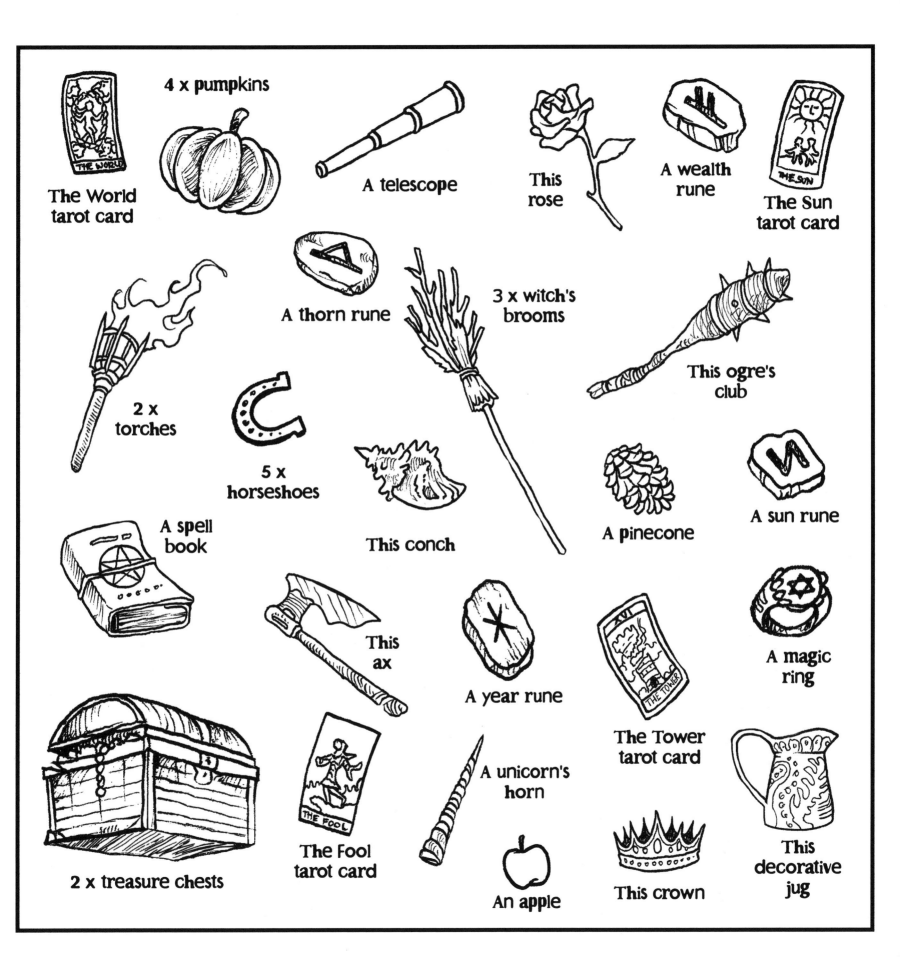

The World
tarot card

4 x pumpkins

A telescope

This
rose

A wealth
rune

The Sun
tarot card

A thorn rune

3 x witch's
brooms

This ogre's
club

2 x
torches

5 x
horseshoes

This conch

A pinecone

A sun rune

A spell
book

This
ax

A year rune

The Tower
tarot card

A magic
ring

2 x treasure chests

The Fool
tarot card

A unicorn's
horn

An apple

This crown

This
decorative
jug

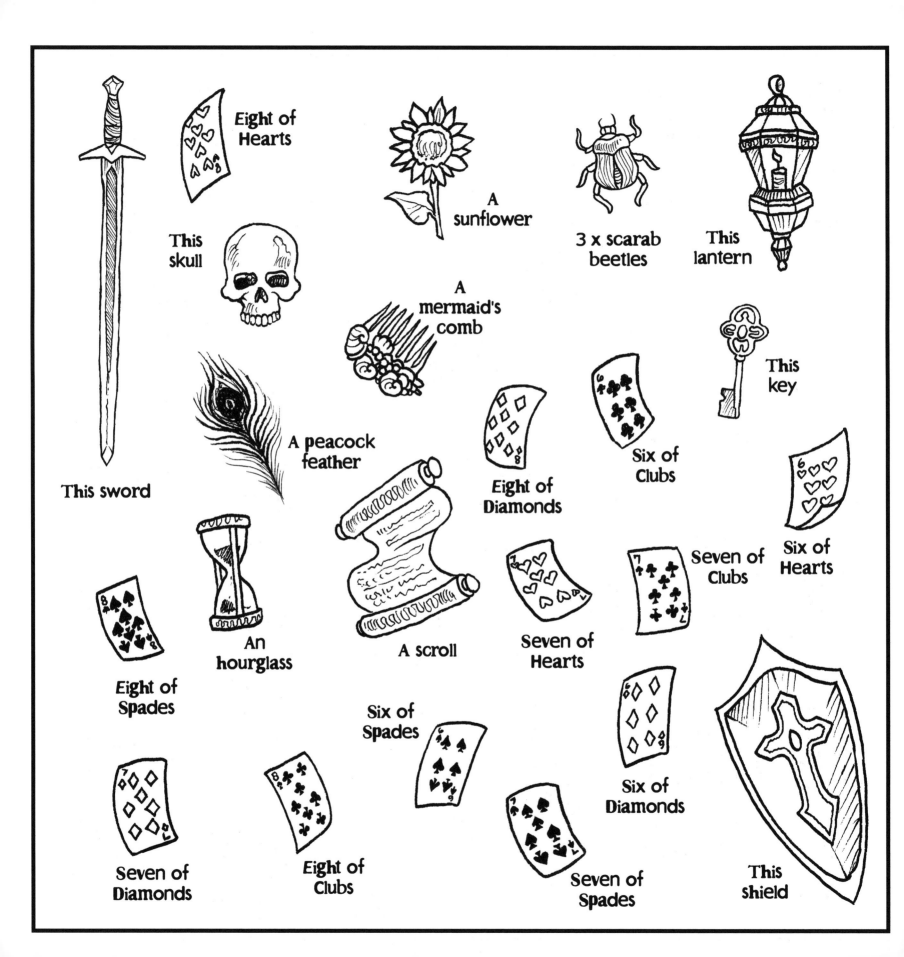

Eight of Hearts

A sunflower

3 x scarab beetles

This lantern

This skull

A mermaid's comb

This key

A peacock feather

Six of Clubs

Six of Hearts

This sword

Eight of Diamonds

An hourglass

A scroll

Seven of Hearts

Seven of Clubs

Eight of Spades

Six of Spades

Six of Diamonds

Seven of Diamonds

Eight of Clubs

Seven of Spades

This shield

All the Answers

Hydra: The World tarot card

Hippogriff: A horse rune, a castle turret, and three pumpkins

Leocampus: A Buddha statue

Hippocampus: A fossil

White stag: A candle

Gnomes: A bow and arrow

Greenman: A sunflower

Jackalope: A conch and
a pumpkin

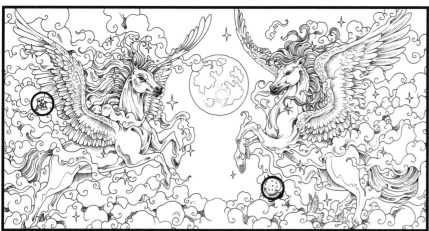

Winged horses: Eight of Spades and a crystal ball

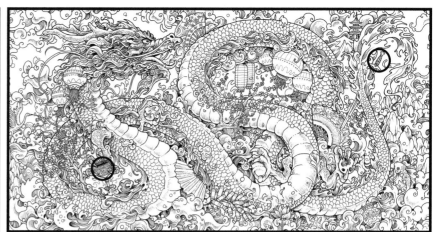

Chinese dragon: A goblet and a sword

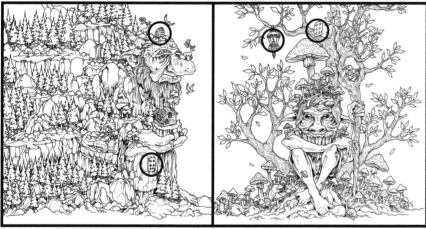
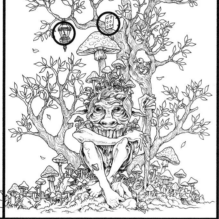

Mountain troll: A dragon egg and Six of Spades

Woodland troll: A lantern and Six of Diamonds

Manticore: A thorn rune and a fairy with a key

Kraken: A telescope

Baku: A scarab beetle

Sandman: A dreamcatcher

Nymphs: A helmet and the Fool tarot card

Kitsune: An antique brooch

Ogre: A scroll and a shield Dryad: A goblet

Mystical Mountains: A knight's glove and an ogre's club

Aspidochelone: A witch's broom and a dragon's egg

Underwater World: A crown and an anchor

Werewolf: The Sun tarot card and a wealth rune

Centaur: Seven of Diamonds and a spell book

Water dragon: Eight
of Clubs

Fire dragon: Eight of Hearts
and a mermaid's comb

Sphinx: A horseshoe and a year rune

Griffin: A dragon claw necklace and Eight of Diamonds

Minotaur: A rose

Phoenix: A key and
Seven of Hearts

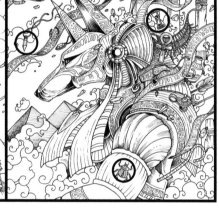

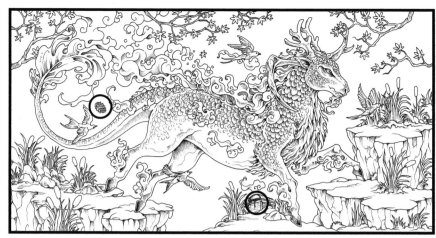

Gorgon: The Tower tarot card

Faun: A scarab beetle and Seven of Clubs

Kirin: A pinecone and a treasure chest

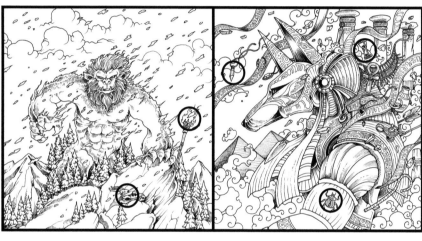

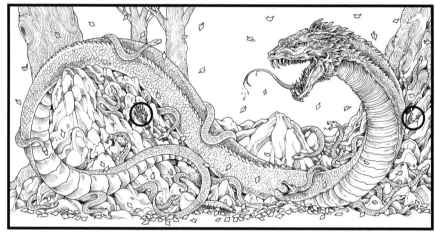

Yeti: A torch and a dragon's skull

Anubis: An amulet necklace, an hourglass, and a scarab beetle

Basilisk: A witch's broom and a horseshoe

Arachne: A horseshoe

Echidna: A dragon's egg

Foo dog: A cauldron

Goblins: A flower crown

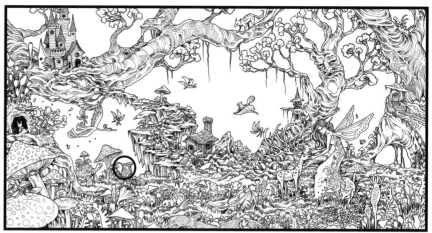

Fantastical Forest: A decorative jug

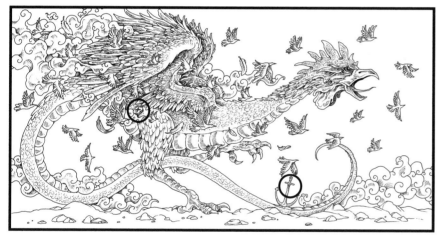

Cockatrice: A gift rune and an anchor

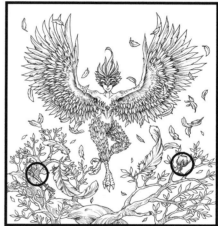

Harpy: An ax and a goblet

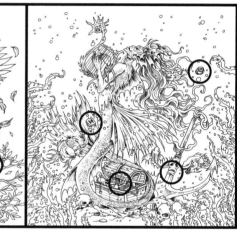

Siren: A magic ring, a sun rune, a treasure chest, and an anchor

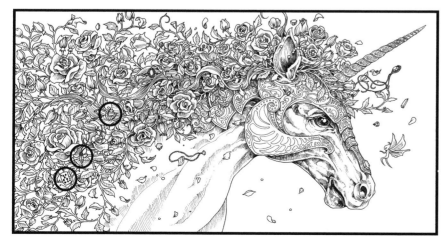

Unicorn: A horseshoe, Seven of Spades, and an amulet necklace

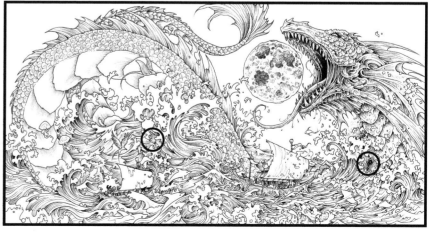

Bakunawa: A witch's broom and a peacock feather

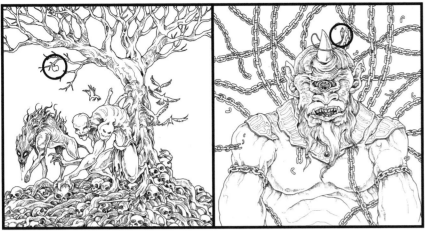

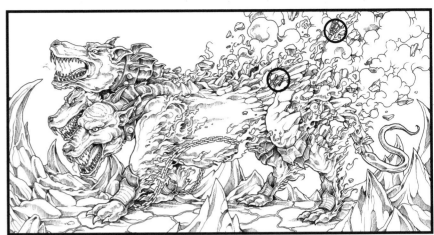

Ghoul: An apple

Cyclops: An amulet
necklace

Cerberus: A horseshoe and a torch

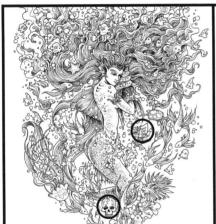

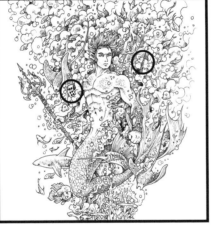

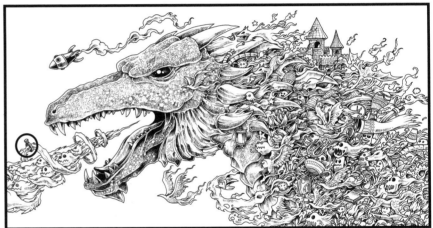

Mermaid: Six of Hearts
and a skull

Merman: A unicorn's horn
and Six of Clubs

Dragon: A diamond ring

The end

Share your creations:
#mythomorphia